CREATIVE CALLIGRAPHY
Made Easy

A BEGINNER'S GUIDE TO CRAFTING STYLISH
CARDS, EVENT DECOR AND GIFTS

Karla Lim, FOUNDER OF WRITTEN WORD CALLIGRAPHY AND DESIGN

PAGE STREET
PUBLISHING CO.

PAGE STREET
PUBLISHING CO.

First published in 2020 by

Page Street Publishing Co.

27 Congress Street, Suite 105

Salem, MA 01970

www.pagestreetpublishing.com

Distributed by Macmillan, sales in Canada by The Canadian Manda Group.

24 23 22 21 20 1 2 3 4 5

ISBN-13: 978-1-64567-134-3

ISBN-10: 1-64567-134-8

Library of Congress Control Number: 2019957314

Cover and book design by Rosie Stewart for Page Street Publishing Co.

Photography by Karla Lim

Printed and bound in the United States

dedication

For my husband, Clement; my son, Chase;
and my good friend, Brooke, for the unconditional love
and support of my dreams.

Contents

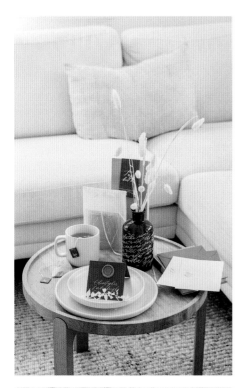

FOREWORD

Calligraphy has allowed me to venture on an incredible artistic journey filled with many discoveries and surprises. One of those delights has been meeting people from around the globe and making good friends along the way. I was first introduced to Karla Lim and her business, Written Word Calligraphy and Design, through a mutual friend. We quickly discovered that in addition to our shared love for all things related to calligraphy—inks, papers, tools and supplies—we shared the same philosophy of finding beauty in imperfection. And although we share this philosophy, if you were to view our work side by side, you would notice our styles are actually quite different. I touched on this topic of developing your own style in the book I wrote, *The Gift of Calligraphy: A Modern Approach to Hand Lettering with 25 Projects to Give & to Keep*. Creating a style that is your own is actually encouraged within the principles of modern calligraphy. You may even notice that elements of your own handwriting will come through each and every time you practice calligraphy!

Karla's graceful and elegant hand shines throughout each project showcased in this book. Her approach is easy to follow and the exquisite styling and ideas are dreamy. *Creative Calligraphy Made Easy* is a book that I wish I'd had access to when I was a beginner twenty years ago. It's been wonderful to watch Karla grow her business into what it is today. She has proved that passion, hard work and dreaming big can lead to tremendous opportunities. Congratulations, Karla—I am deeply humbled and honored to be a part of it.

Maybelle Imasa-Stukuls
Artist, author, calligrapher and designer

INTRODUCTION

Hi, new calligraphy friend! I'm so glad that you are here. This book is a culmination of my creative energies, sharing what I love: calligraphy. Calligraphy is an amazing skill to have, and I love it because once you get the hang of it, there are many different ways you can apply it—handmade cards, wedding details, personalized gifts and projects for your home that you can be proud of. Also, there's just something special about calligraphy—it is therapeutic and meditative. In fact, I spend a lot of my days writing letters and strokes, with some relaxing music on in the background, and it helps me focus and calm down amid the chaos of my bustling work and life.

In this book, I'm going to share my passion and vision with you. You'll learn all about the foundations of calligraphy, from the basic strokes to lowercase and uppercase letters to connecting letters to make words. Then, with your newfound calligraphy skills, you'll learn how to apply them by creating curated and personalized projects that are bound to warm your loved ones' hearts.

Oh, by the way, my name is Karla. I'm the founder and owner of Written Word Calligraphy and Design, a modern calligraphy design studio based in Vancouver, Canada. Written Word offers calligraphy education, wedding stationery design and calligraphy products. I'm all about intention and cohesion in my work. After discovering calligraphy as a hobby and as a relaxation method, I have since wanted to share calligraphy with students all over the world so that they can also discover the joy of writing beautifully. Drawing on my years of experience in crafting, as well as my purposeful, creative style, I created the calligraphy projects in this book—projects you're going to really love. As you go through this book, you're going to see my favorite color palettes, my minimal, modern approach to design and my crafting style. If you want to know more, visit my website at writtenwordcalligraphy.com.

Learning calligraphy is a journey. Don't worry too much if you think that your handwriting is "terrible" or if you don't like to write in cursive, because calligraphy is approached and written differently. It requires different tools and different ways to hold the pen—because of those differences, calligraphy will require time, practice and adjustments to get better. It isn't always easy, but it is doable. And once you get it right, the opportunities are endless. The longer you practice calligraphy, the more your work will progress and grow. The learning curve is different for every student, but I know you can do this. With the proper tools, technique, practice and direction, you will learn to write calligraphy beautifully.

Are you excited to learn calligraphy and how to apply it in many beautiful and creative ways with me? I cannot wait to see what you will create! Let's get started.

Karla Lim

GETTING STARTED IN MODERN CALLIGRAPHY

WHAT IS MODERN CALLIGRAPHY?

Before we get started learning how to write in modern calligraphy, let's talk about what calligraphy is all about. By definition, calligraphy is the art of producing decorative or artistic handwriting using a pen, brush and related tools. Historically, there are styles that were meant to be written in a certain manner consistently, with established letterforms, such as traditional calligraphy like Copperplate or Spencerian.

People were required to write them in the exact same way, just like how we would use a font. There were preexisting rules to follow, such as writing with specific slants, sizes, shapes and so on. Modern calligraphy uses the exact same tools as traditional pointed-pen calligraphy but you set your own "lettering rules," styles, flourishes and more. When you use a pointed pen to write in calligraphy, you will be going back in time, dipping a pen into an inkwell and writing with a flexible, pointed nib. The flexible pointed pen creates thin and thick lines when you write, which leads to the signature look of modern calligraphy. I always think of modern calligraphy as drawing or painting letters and words, rather than simply writing them to be read. Modern calligraphy is truly an artistic expression!

MODERN CALLIGRAPHY VERSUS HAND LETTERING

Once you grasp the concepts of modern calligraphy, it will be easier for you to apply them to other kinds of lettering, such as brush lettering and hand lettering. Learning modern calligraphy provides you the foundation you need to understand how the letters should look and how they should connect. Brush lettering uses a brush instead of a pointed pen, so it yields a different end product when you write. We will be creating some projects using a brush in this book, so you'll get to try your hand at brush lettering as well. On the other hand, hand lettering uses various tools that mimic the look of modern calligraphy, such as having thick and thin lines, but hand lettering has the flexibility of writing on various surfaces. Because the hand-lettering tools don't typically have the ability to create thick and thin lines, you will have to manually thicken the lines. In this book, we will also be working on other surfaces besides paper, so you will get the chance to try hand lettering as well.

Another important point to remember is that handwriting and cursive writing are different from calligraphy. Your day-to-day handwriting, as well as cursive writing, is more a functional style of writing—you are writing to be read. But calligraphy and many kinds of lettering are more of an art form, an artistic expression, that use various tools and styles to create the final product. Here's an illustration to demonstrate a few of those things that make all of these styles of writing different.

EVEN PRESSURE

CONNECTED LETTERS

Hello

hello

HANDWRITING

CURSIVE

WRITING TO BE READ

TALLER LETTERS THAN HANDWRITING

USUALLY WITH SLANT

LINES THICKENED MANUALLY

hello

hello

Hello

CALLIGRAPHY

BRUSH LETTERING

HAND LETTERING

WRITTEN W/ PEN, NIB & INK

VARYING PRESSURES WHILE WRITING

WRITTEN W/ BRUSH

APPLICABLE ON MANY SURFACES

WRITING AS AN ARTFORM

Leaving early, happens all the time, managers switch → personality → looking to leave early

9

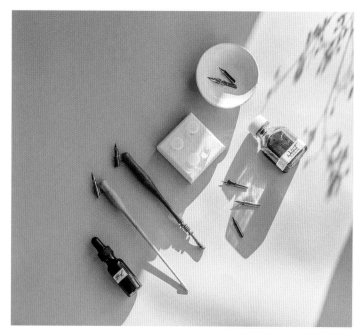

A few of my favorite tools for pointed-pen calligraphy.

You can purchase your essential tools for pointed-pen calligraphy from writtenwordcalligraphy.com/starterkit.

YOUR ESSENTIAL TOOLKIT FOR LEARNING CALLIGRAPHY

The next step in learning calligraphy is to fill up your toolkit with the right materials. Calligraphy doesn't require a lot of tools, but having the right ones will definitely help you write well. The four key things you need are: (1) nibs, (2) a pen, (3) ink and (4) paper. I still recall my first trip to the art supply store, scouring aisle after aisle, reading every single product label, trying to figure out what I needed to purchase to create calligraphy. It was overwhelming—I wasn't sure what I needed, and I wasn't sure which tools were best. After much trial and error, I came up with a tried-and-true list of tools I recommend using, which I will be talking about a lot throughout this book. For details on where to get items, refer to the resources section (page 170). Sometimes you can get supplies in-store at your local art supply shop, but a lot of the supplies are best found online. I have also curated my very own calligraphy starter kit, which includes my favorite supplies. If you're interested in getting your hands on one of those, visit my online shop at writtenwordcalligraphy.com/starterkit.

Here's what you need to get started:

1 **Nib:** Nikko G or Zebra G.

2 **Ink:** Best Bottle sumi ink or Moon Palace ink.

3 **Pen:** Written Word Dual Purpose Calligraphy Pen or Paper & Ink Arts Hourglass Adjustable Oblique pen.

4 **Paper:** This book will provide worksheets for you to practice, but for further practice, I recommend the HP Premium32™ paper.

A DEEP DIVE INTO CALLIGRAPHY TOOLS

Now that you've got your essential toolkit, let's talk about the nitty-gritty of these calligraphy tools. Behind a beautiful calligraphy project is a harmonious relationship between the tools and, of course, the calligrapher. For example, there are some nibs that work better with certain kinds of ink and paper, so when you understand a little more about the tools, then you can find your "secret sauce" of calligraphy tools as well.

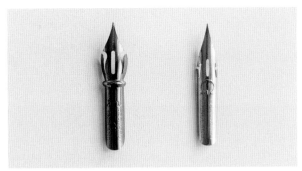

Brause 361 nib (also known as Blue Pumpkin nib) and the Nikko G nib

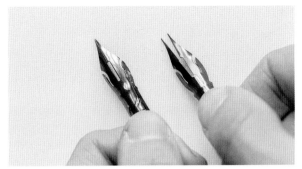

Nib on the left —tines are closed; nib on the right—tines are open.

POINTED NIBS

What Are Nibs?

Nibs are the tips of the pen. They vary in style, size, flexibility and pointedness. For this style of calligraphy, you will need pointed nibs, which are nibs that come to an absolute point, or have a pointy end. Other nibs have a flat tip or a circle at the end, which will not work for this style of calligraphy. Trust me, I have learned the hard way. So make sure the nibs you get are correct—or else they will not achieve the desired look.

The varying sizes of nibs also determine the height of letters a particular nib is able to write. Shorter nibs tend to write smaller, more delicate letters, while taller nibs have the flexibility of writing larger letters. It is also a matter of preference for the calligrapher, as taller nibs can be harder to write with for some people, or vice versa. Your choice of nib depends on the letters you would like—and your comfort level too! Smaller nibs also tend to hold less ink, so you may need to dip it into the inkwell more often than taller nibs. As for flexibility, nibs can vary from very stiff to very flexible. Again, this depends on the preference of the calligrapher, or their writing style. If you have a heavy hand, it might be easier for you to write with a stiffer nib. Stiffer nibs tend to create less variation between the strokes, while flexible nibs are able to create really thick downstrokes (the widest lines a nib can make). Some nibs are also pointier than others and can create thinner upstrokes (the thinnest lines a nib can make).

Parts of the Nib

All pointed nibs have two metal pieces that come to a fine, sharp point. These two metal pieces are called the tines. The fine, sharp point is called the tip. On the nib, there is also a hole in the middle of the nib, which is called the vent hole. The concave part of the nib is the reservoir, where the ink sits.

When the nib is at rest, the tines are perfectly aligned with each other and touch.

Try these two exercises to understand how the nib works!

Exercise 1:

1 Hold the nib with the curve facing downward and press the tip down onto the paper. The tines will open up and splay outward.

2 Drag the tip downward on the paper while simultaneously pressing down. You'll notice that the tines stay open.

When the tines are open like this, the ink will flow through and create a wide stroke. This means that when you are writing downward and pressing down on the nib, you will create thick lines, which are called downstrokes (they are also called swells).

Exercise 2:

1 Hold the nib with the curve facing downward again, and lightly press the tip down onto the paper.

2 Drag the tip upward on the paper without pressing down. You'll notice that the tines are closed and stay closed.

When the tines are closed like this, the ink will still flow, but it will be rather light and will create a thin stroke. This means that when you are writing upward, or horizontally, you will create thin lines, which are called upstrokes (they are also called hairlines).

Nibs PSA

Nibs don't last forever! Because they are metal pieces and the tip is a sharp point, after time and use, the tip will no longer be as pointed. What this means is that the upstrokes may no longer be as thin as they used to be, or the nib may feel scratchier on paper than when you first started using it. When either of these things happen, you'll know it's time to say goodbye to the nib and start anew with a fresh, unused nib. From my experience, this dulling can happen to a nib after a full day of writing addresses or a few weeks of using the nib daily for 30 minutes.

While modern calligraphy can be applied to various other media aside from paper, nibs are best on paper. In order to write on materials aside from paper, some surface preparation may be necessary. However, some media just will not work with nibs, so you may need to use other tools—such as markers or brushes—if you want the look that nibs create. In this book, you'll find creative projects that show you how to take your calligraphy skills beyond the nib and paper.

Finding the Right Nib

I like to use the analogy that nibs are similar to how a photographer can have different lenses, and lenses have specific uses for different types of photography. In the same manner, there are nibs that are apt for writing on smooth paper and nibs that are better for writing on textured paper. Pointedness has something to do with that—sharper, more pointed nibs are better on smooth paper, while nibs that are less pointy are better suited to writing on textured paper, such as handmade deckled paper. Writing with different nibs will definitely feel different and look different! I recommend that you purchase a whole slew of nibs to find the right fit for you, your writing style and the project you're aiming to work on. It's a bit like speed dating, but with nibs! In the resources section (page 170), I have listed a number of my favorite nibs and what I love about them.

To get started, I recommend the Nikko G. It writes just like butter and is a slightly stiffer nib, which will help you learn control. If you aren't able to get this nib, the Zebra G is also a great option.

PENS

The next most important thing in calligraphy is the pen, which holds the nibs. There are two main kinds of pens: The first is the straight pen, and the second is the oblique pen. The straight pen, just like its name, holds the nib straight. The oblique pen holds the nib at an angle. The pen's shape affects the angle of the nib as you write on the paper, so it is a matter of preference for the style that you are going for. Traditionally, certain script styles needed to be written with a specific angle, so the oblique pen holder was created; but with modern calligraphy, you can write with a straight angle or a super slanted one. Historically, the oblique pens were created for right-handed calligraphers, and the straight pens were more suited for left-handed calligraphers; however, it is really a matter of preference and ease. I do highly recommend writing with an oblique pen as a right-handed beginner, though, as doing so helps with the posture and the angle that you will be writing with. In the same way, I suggest a left-handed beginner write with a straight pen.

To get started, I recommend using the Written Word Dual Purpose Calligraphy Pen, which is a convertible pen made of lightweight wood and holds the Nikko G well. It can be used as a straight pen or an oblique pen. If you aren't able to get this pen, I have listed my other favorite pens in the resources section (page 170).

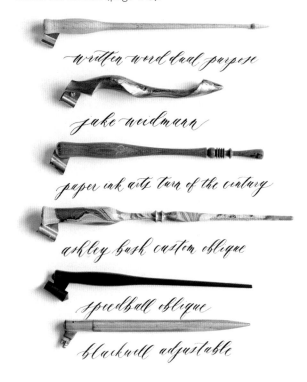

written word dual purpose

jake weidmann

paper ink arts turn of the century

ashley bush custom oblique

speedball oblique

blackwell adjustable

A Note on Fountain Pens

For this style of calligraphy, fountain pens will not work. Fountain pens tend to have inflexible nibs that are not suitable for pointed-pen calligraphy. Additionally, fountain-pen inks tend to not work for pointed-pen calligraphy.

INKS

Traditionally, calligraphers have used ink as the main "paint" for writing. With modern calligraphy, we still use ink, but we are also not limited to the commercially available ink. The beautiful thing about ink as opposed to other media is that it's typically in the right consistency and fluidity to be used for writing. Especially for basic colors and metallic colors, it's the way to go. But for more unique colors, gouache paints (see below), acrylic paints and pigments are a better option.

I use a wooden ink holder to hold my inkwells in place. I've experienced too many ink spills that could have been prevented if I'd been using an inkwell holder!

To get started, I would recommend using sumi ink, particularly Best Bottle sumi ink or Moon Palace ink from John Neal Books. These two inks are really dark and are the perfect consistency for writing, which is great for beginners. If you aren't able to get these inks, please visit the resources section (page 170) for other inks that I recommend.

Gouache

This is what I use to create popular colors that are requested by my clients, such as gray, sage green, dusty blue and dusty rose. The reason I use gouache instead of watercolor for creating these pastel shades is because gouache is much more opaque. For example, in my Rainbow Baby Wishes Card (page 47), I used gouache to create the bright and unique colors and the inks for creating the card. To create ink, start with a little paint and slowly add distilled water until it becomes the consistency of ink. It takes time and a lot of testing and waiting to get to the shade you want, as gouache, like any water-based paint, tends to dry slightly different from the initial color you write with. You will need to put the leftover paint in an airtight container after you are done with it; otherwise, it will dry out and be unusable. It is important to note that using high-quality gouache, such as Schmincke Designers' Gouache, will create a more vibrant color than regular art store gouache or watercolor paint.

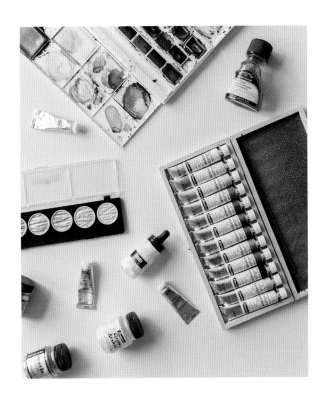

Watercolor

When I'm trying to go for a gradient look in my calligraphy, I reach for my Winsor & Newton watercolor pan set. I love the variety of colors, and I use a paintbrush to paint directly on the nib to create a new shade of color. I love using the set for painting, such as the Earth-Toned Watercolor Birthday Card (page 31), and for creating some gradient inks! An alternative is using Winsor & Newton's Professional Water Colour paint tubes—these are amazing to use for painting and equally as incredible to use for calligraphy.

FINETEC

An alternative to using gold ink is to purchase a beautiful metallic palette from FINETEC. It's an opaque metallic watercolor with different shades of gold. You will need to use a brush to moisten the pigment with water, then, after 30 seconds, you can use the brush to apply the resulting paint onto your nib to write with. I suggest using this method only if you're working with a small project—if you will be writing a lot with gold ink, Dr. Ph. Martin's Iridescent Copper Plate Gold would be perfect for your job.

Pearl Ex

Pearl Ex is powdered metallic pigment that comes in a variety of shades that are not available in ink. I rarely use Pearl Ex, but occasionally I get a job that requires a unique metallic ink or paint that requires me to use it. I follow Bien Fait Calligraphy's recommendation for this pigment brand—which is 4 parts pigment, 1 part gum arabic, 4 parts distilled water—and adjust the ink depending on what I'm working on. Occasionally, I also add some of the powdered pigment to my metallic inks if I'm feeling like they're losing a bit of their shine.

PAPER

While modern calligraphy is limited to paper, the amount of paper choices can truly be overwhelming. Some paper materials work better than others, so here are some guiding principles:

1 The smoother the paper, the better.

2 Uncoated paper suits calligraphy more than coated papers.

3 In general, thicker paper works better with calligraphy. Thin paper may work, depending on how absorbent the paper is. Otherwise, it may feather, creating fine lines in the paper due to ink spread.

4 When in doubt, test the paper!

This book provides you with art paper with printed worksheets that you can use to write and practice. When you need additional paper, I recommend purchasing HP 32lb paper or Rhodia brand paper pads.

Aside from paper, there are many media that you can write calligraphy on as well, but you will have to test each one to see if it will hold ink well. Don't worry—in this book, I'll be sharing all my tips and tricks for those various materials, such as leather, linen, ribbons, glass and acrylic, as well as what tools work best! And starting on page 170, you'll also see a list of those specific tools and where to get them.

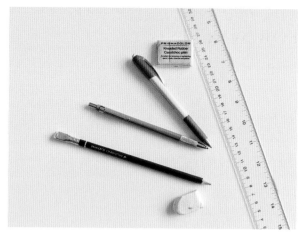

From bottom left to top right: eraser, Blackwing pencil, Staedtler Mars Technico pencil, Fons & Porter White Chalk pencil, rubber kneaded eraser and ruler.

OTHER MATERIALS

Pencil and Eraser

I like using a soft graphite pencil (like a 9H) to draw the words first, in order to perfect the positioning and style, and then write over the words in calligraphy with pen and ink so that I do not have to write things multiple times. A mechanical pencil works well, too, and keeps the lines thin and easy to erase. Aside from a regular pencil, I also use a white chalk pencil from Fons & Porter®. I use this specifically for paper or materials that are not white, so that I can see my outlines before I write over them.

For erasing, I use a kneaded rubber artist eraser that does not create residue. However, sometimes you'll need a regular eraser, and I recommend using a retractable white stick eraser for spot erasing around text—that way you won't smudge the calligraphy.

Measuring Tools

You'll need rulers and guides to help you create your artwork so that it is centered and outlined in the manner that you have intended. For a lot of my projects, the measuring takes more time than the actual calligraphy work. But it helps so much to measure, because it reduces mistakes and helps you get it right the very first time.

PREPARING YOUR TOOLS FOR WRITING

PREPARING THE NIB

Before you start writing with your new nibs, you will need to prepare them for writing. They come with a waterproof coating as a result of the manufacturing process, which makes it difficult to write (I learned this the hard way). If you don't prepare your nibs, the ink will bead up and will not flow normally for writing.

The quickest batch method I use for preparing multiple nibs is to use hot water, some dishwashing liquid and a dish towel. I soak the dish towel with some hot water and dishwashing liquid and scrub each nib to help remove that residue. Alternatively, you can use an old toothbrush to scrub off the coating. A few seconds per nib should be enough. After washing the nib, dry it completely as you don't want any liquid to dry on the metal nib and cause it to rust.

My quick and dirty method when I need to prepare a nib on the fly is to use ink! I dip the nib into my inkwell, then I use a piece of tissue and use the ink as a solvent to rub off the coating, so I can write with the nib right away.

Remember, you will only need to do this preparation process the first time you use the nib. Once you've done it once, you won't need to do it again.

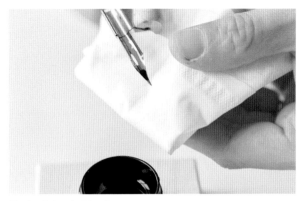
Dip the nib into the inkwell.

Use a paper towel or a napkin to rub ink off the nib.

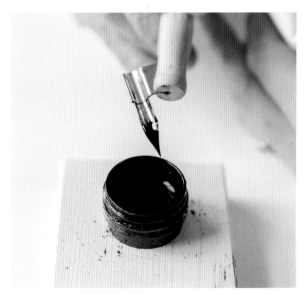
This is how your nib should look after you prepare your nib.

Two kinds of straight pens—one with a circular flange and one with a pronged flange.

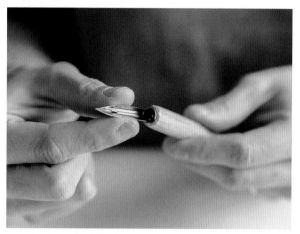

Insert the nib into the straight pen until it is snug.

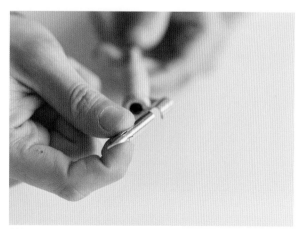

Oblique pen: Insert the nib into the flange. When the pen is facing you, the flange should be on your left side.

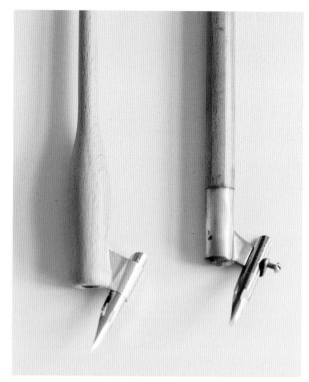

This is how your nib should look on an oblique pen. If you drew an imaginary line downward from the tip of the pen, it should align to the midpoint of the pen.

INSTALLING THE NIB

Straight Pen

Install the nib into the groove of the nib holder. If the end of your straight pen has a metal rim and four prongs on the inside, insert the nib on the outside of the four prongs (between the prongs and the rim).

Oblique Pen

When holding the pen, the elbow section must be on your left-hand side. Install the nib into the elbow with the curve facing away from you. You want to insert it down until the tip of the nib aligns with the midpoint of the pen. With some of the taller nibs or depending on the way your pen is constructed, it may not be possible to align this, but just insert the nib as snugly as possible and it will be all right.

DIPPING THE NIB INTO INK

You should dip the nib past the vent hole to get as much ink as possible in the reservoir. You do not need to tap the ink out, as you may have seen in movies; instead, brush the back of the nib at the rim of your ink bottle to remove excess ink. This will help keep the first few strokes from being overloaded with ink.

A common question I hear is, "How often do I have to dip?"

It depends! There are a few factors determining the answer to the question:

1. **Nibs:** Some nibs carry more ink than others. More flexible nibs also mean wider downstrokes, which means more ink will flow out for those.

2. **Writing style:** If you write with a heavy hand, more ink may flow out.

3. **Height of letters:** Depending on how tall or small your letters are, your ink usage will vary.

From my experience, a medium-flexibility nib used with medium pressure will produce one or two words (or more) after one dip. Most beginners dip frequently, and as you get better with practice, you will be able to fine-tune the process and dip only when necessary.

CLEANING THE NIB

When you are looking to pause writing for a short time, use a paper towel and a spray of water to wipe the ink off the nib. When you are done writing, remove the nib from the pen and wash the nib thoroughly to prevent the ink from drying on the nib. When the ink dries on the nib, the tines may not close properly or the reservoir might not hold ink properly, which will reduce the life span of the nib.

HOLDING THE PEN

Now it's time to learn how to hold the pen. In general, we want to hold the pen ½ to 1 inch (1.3 to 2.5 cm) from the end of the nib holder in a medium, comfortable grip. We also want to make sure that the nib curve is facing away from us and facing the paper when we press the tip onto the paper.

There are two key angles that are important to writing pointed-pen calligraphy. Let's take a look at them both.

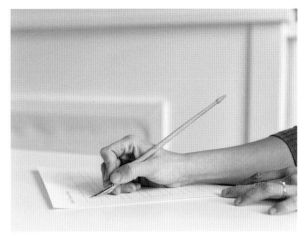

Ideal angle for holding the pen—30 to 45 degrees from the paper.

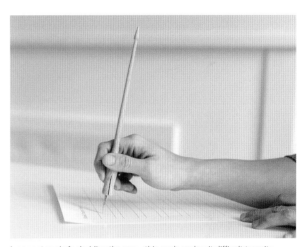

Incorrect angle for holding the pen—this angle makes it difficult to write.

Angle 1

The first angle we need to examine is the angle of the pen itself from the paper. You want to hold the pen 30 to 45 degrees from the paper. This is the optimal angle for the nib to work. Unlike brushes, calligraphy nibs aren't flexible enough to flip up and down. This angle does not vary much while you write. If your angle is too high from the paper (i.e., if you are holding the pen like a brush), it will be very difficult to write and you will hear a lot of resistance and scratchiness from the nib. If your angle is too low, it will be uncomfortable for you to write and the nib may release more ink than you intend.

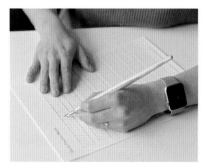

Angle 2—Align your nib to the slant you're writing with.

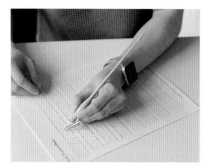

Incorrect angle—the nib is not aligned to the slant.

Ensure you are writing below the baseline, as reflected in the photo.

Using a straight pen may be easier for lefties!

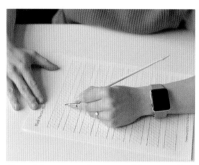

Alternately, you can also use an oblique pen. As a leftie, you may need to twist your paper to the right more to write comfortably.

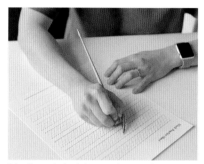

Friendly reminder, leftie or rightie—make sure your angle 1 and angle 2 are correct!

Angle 2

The second angle to discuss is the direction of the nib. The rule of thumb is to align the nib parallel to the slant you are trying to write. Typically for calligraphy, there is a slight slant to the right. In traditional calligraphy, such as Copperplate, it is a pretty steep 55 degrees from the horizontal. In modern calligraphy, this slant will usually vary per each calligrapher's style: It could be more upright, like 90 degrees from the horizontal, or slightly slanted, about 70 degrees, or even slanted 55 degrees or fewer from the horizontal. This slant will depend on the overall look you are going for. The key thing is that you will need to maintain this angle for writing, because this is the optimal position for the nib tines and the ink flow, which both greatly affect the resulting letterform. There will be a learning curve here as this varies quite differently from how we write regularly.

When you align the nib parallel to the slant, your pen automatically moves to the bottom of the baseline, which means your hand will be positioned quite low, versus being right beside the letters as it is when you're writing normally. This is good for calligraphy, because calligraphy letters tend to be large, and having your hand positioned below the baseline

will help the nib write more smoothly and in the right direction. Especially with letters with descenders (i.e., the lower loops), it will be easier to write them when your pen is positioned lower, as doing so will help the nib be at the right angle (angle 1). Now, you may feel like your body seems rather awkward with your hand positioned below the line, so feel free to adjust your paper to slant to the left so that more of your right arm is on the table for stability. Additionally, you want to make sure that most of your arm is on the table when you are writing.

Note for left-handed calligraphers

If you are left-handed, the same principles apply. I have taught dozens of left-handed calligraphers and their learning curve, while it may vary from one leftie to another, it is pretty similar to a rightie's learning curve. Angle 1 and angle 2 still apply. To be honest, the second angle may be easier to implement for a leftie. And the hand being positioned below the baseline will also help prevent smudging, which is common with lefties. One of the biggest tips is that you will need to adjust the paper by moving the top of the paper slightly to the right. This will help writing become more comfortable for you.

HOW TO WRITE

Now that you know how to install the nib, how to hold the pen, how to dip the pen into the ink and the two most important angles in calligraphy, it's time to learn how to write!

Here are the general rules for writing in calligraphy:

1 Whenever you're writing downward, you write with pressure. This means you are pressing down when you write, and you create the thickest lines your nib is able to make (also called swells).

2 Whenever you're going upward, you write with very little pressure. This will feel like you're hovering over the paper, and you create the thinnest lines your nib is able to make (also called hairlines).

3 Whenever you're transitioning from thick to thin lines, you will want to decrease pressure about four-fifths of the way down the stroke. By the time you hit the bottom of the stroke, the line will be thin. This is the bottom transition point.

4 Whenever you're transitioning from thin to thick lines, you will want to increase pressure at the very top of the stroke. This is the top transition point.

5 Whenever you're writing horizontal strokes, you write with very little pressure, like hairlines.

6 When you write in calligraphy, write slowly—even five, ten or fifteen times slower than usual. In fact, if you need to, pause at every stroke. You don't need to finish each letter completely in one pen stroke; you can break it down in order to focus on the shape of the letter.

You will see the word pressure a lot from me through learning the letters in this book, because it is what sets calligraphy apart from regular handwriting. We typically write with even pressure with regular handwriting, but writing calligraphy is similar to driving a car. When we're beginners in driving, we step on the gas or the brake pedal rather abruptly and the ride is usually a bit bumpy. But as you practice driving and improve at it, the drive and the ride become smoother.

These days, we really don't write as often, and we definitely don't stop to think very much about how our letters look. But calligraphy is an invitation for rediscovery and creativity. It invites us to slow down and think about the shapes and intention behind every stroke, rather than just writing simply to be read. Because of that, writing in calligraphy is typically slower than usual handwriting. It is more intentional, technical and purposeful, which is what I love about it.

DOWNSTROKES

UPSTROKES

TOP TRANSITION POINT

BOTTOM TRANSITION POINT

HORIZONTAL STROKE

SQUARE TOP

SQUARE BOTTOM

CALLIGRAPHY STEP-BY-STEP GUIDE

I'm a firm believer of the saying "practice makes progress." It will take time to gain these new skills, so be patient with yourself. In order to create the projects in this book, I recommend a six-week practice plan. Of course, you can certainly jump in and start doing some projects as you start polishing your calligraphy skills.

SIX-WEEK PRACTICE PLAN

Practice 30 minutes a day, 5 days a week. Choose a time of day that works best for you to learn, then create a reminder on your calendar or phone to help you practice calligraphy. Optionally, add some relaxing music to your practice time. You will start off with practicing on the sheets in this book, then you can practice calligraphy on some of the recommended paper on your own.

Week 1: Practice for 15 minutes with the calligraphy strokes, then spend 15 minutes with lowercase letters.

Week 2: Practice for 5 minutes with the strokes, then spend 25 minutes with lowercase letters.

Week 3: Practice for 5 minutes with the strokes, then spend 25 minutes with lowercase letters.

Week 4: Practice for 5 minutes with the strokes, then spend 25 minutes with uppercase letters.

Week 5: Practice for 5 minutes with the strokes, then spend 15 minutes with uppercase letters and 10 minutes connecting letters.

Week 6: Practice connecting letters to make words and short quotes.

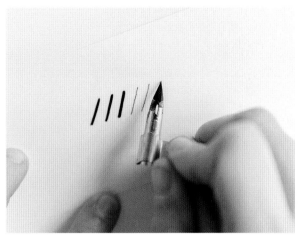

Downstrokes and upstrokes are the foundations of pointed-pen calligraphy.

Once your hands are warmed up, you can move on to writing the lowercase letters.

PRACTICE EXERCISES

The first step in learning how to write in calligraphy is to learn the practice strokes. After that, you will learn how to write the letters. From years of experience in teaching calligraphy, I have found it easiest for students to learn the lowercase letters first then the uppercase letters. Once your letters have become more consistent, you may start to practice connecting the letters to make words.

Why is learning the practice strokes so important?

Michael Jordan once said that when you master the fundamentals, the level of everything you do will rise. The practice strokes are the foundation of calligraphy letters. When you combine the strokes, they make up the letters of the alphabet. Additionally, it helps you discover what needs to be troubleshooted in order for you to write well: grip, angle or nib, pen, ink or paper issues. On top of that, practicing the basic strokes will warm up your hand to help you craft those letters well. Every practice time starts with the practice exercises first.

In the worksheets, you will practice tracing the strokes first, then you will be writing them on your own using the guidelines. Use as a guide for the slant by aligning your nib to those lines. You can do this!

Start practicing on page I.

LOWERCASE ALPHABET

After you are done with learning the practice strokes, you may start learning the lowercase letters. The letters start with the smallest of letters, then progress to letters with ascenders and then to letters with descenders, instead of in alphabetical order. And remember, equally as important as practicing is resting. Waiting for the ink on your sheet to dry is a great time to pause and stretch your hands, neck and shoulders before you continue.

In the worksheets, you will notice that there are instructions and notes for each letter. Then each letter will have two variants, each having traceable letters and then blank spaces beside them for you to practice with the pen and ink. The variants are there to help spark your creativity and your muscle memory by allowing you to explore different styles. The first style is one of my signature styles, Gossamer. It has a romantic yet free-spirited feel to it. The second one is a bit more playful, with rounder letters, called Lissome. As you learn modern calligraphy, eventually you will have the skills needed to create your own calligraphy style. I can't wait to see how you do with these letters!

Start practicing on page IV.

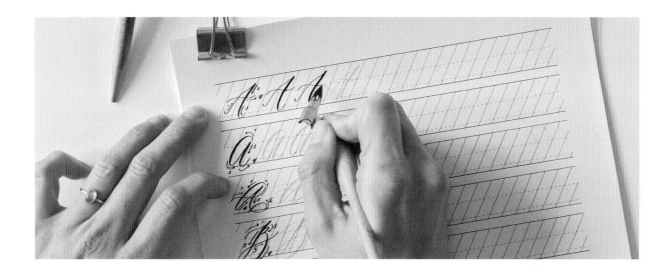

UPPERCASE ALPHABET

Once you have gotten the hang of writing lowercase letters, you may proceed to learning the uppercase letters. Just like the lowercase alphabet, there will be instructions and notes for each letter, and each letter will have two variants, Gossamer and Lissome, so that you can take them as inspiration to create your own eventually. Over time, you will see your own style emerge.

Start practicing on page XIV.

CONNECTING LETTERS

The foundation of connecting letters lies in your strokes. When your basic strokes improve, your lowercase and uppercase letters will improve as well, and when your lowercase and uppercase letters become consistent, connecting them will be a breeze. My number one tip for connecting letters is to start with writing the letters individually first, side by side. Then you can manually connect them. Getting to the level of consistency for the letters will take time, so only when you've gotten to week 5 or 6 would I recommend that you start connecting letters to make words.

Creating variations in connecting is part of the unique quality of modern calligraphy. Every person will connect letters differently. Connections will vary from person to person, from style to style. Once you get the feel of Gossamer and Lissome, you can keep exploring to find your own unique style.

Here are some ideas:

1 **Clean and simple:** No variance in distance between letters.

2 **Airy and spacious:** A ton of distance between letters.

3 **Tight and close:** Very little distance between letters.

4 **Doubling up:** One of the letters is slightly larger than the other when you have double letters.

5 **High and low:** Varying the heights between letters.

In terms of connecting uppercase and lowercase letters, the beauty of modern calligraphy is that you can make your own rules! You don't need to connect the letters all the time, but you can certainly choose to if you are able to connect the larger letter with the smaller letter without making it look awkward.

Here are some ideas:

1 Write the lowercase letters at the baseline.

2 Write the lowercase letters slightly higher than the baseline, not necessarily connected.

3 Write lowercase letters at the midline, not necessarily connected.

Start practicing on page XXIII.

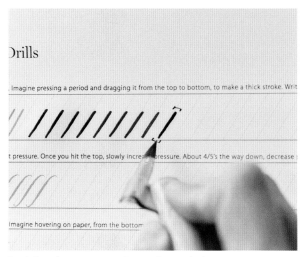

Reminder to keep a square top for your downstrokes!

WORKSHEETS

In the worksheets, you're going to finally learn how to write in calligraphy. Make sure that you have your workplace and tools set up for writing.

Follow this checklist:

1 The nib is prepared to write and is installed into your pen.

2 The ink bottle has been shaken and placed in an ink holder.

3 The paper is ready to be written on.

4 Your space is well lit and you have a table with a chair that is an appropriate height for writing.

TROUBLESHOOTING

How is your journey in learning calligraphy going? As I mentioned earlier in the book, learning calligraphy is a journey: There will be some highs and lows, and each one of those experiences will help shape your style and letters. I have compiled here a list of troubleshooting tips for writing in calligraphy, which I hope will help you.

"My first few strokes have so much ink. Why is that?"

Make sure you are brushing the back of your nib on your inkwell. If necessary, use a piece of scrap paper to test out your strokes. Write two strokes on the scrap paper first, then continue writing on your practice paper.

"My nib keeps catching paper fibers."

Double-check your angle 1. Especially when you're writing upstrokes, you need to have the feeling of gliding across the paper rather than getting stuck. Keep the pressure really light when you're writing the upstrokes.

"My strokes are feathering on the paper."

This can be a problem related to the paper or the ink, or it could be that there's too much ink on your nib. Make sure you are using the correct tools, and if you are, most likely there's too much ink on your nib. Reduce the pressure a bit while writing. In fact, start with very little pressure, then slowly increase your pressure until you get the thickness of strokes you are aiming for.

"My lines are so squiggly."

This is something that is going to take some time to improve. Practice with a pencil and write ovals nonstop using the worksheets. Aim to write one oval between the guidelines, and repeat the process over and over again. The muscle memory of the ovals will help the shapes of your strokes.

"The tops of my letters are pointy. Is this normal?"

Downstrokes need to have a "square top," or a heavy stroke. This means you will need to write with pressure from the beginning, so the tines can open up and create a thick stroke right away.

"The bottoms of my letters have slight tails. How do I fix this?"

Downstrokes also need a "square bottom," or a heavy stroke. This means you will need to end the stroke with pressure, so the tines can open up and finish with a thick stroke.

"My letters are not consistent. What do I do?"

Take advantage of the guidelines in the book in order to practice. Writing between the lines, focusing on the slants and the shapes, and working slowly will help you. Remember that learning calligraphy will take time. After you finish the worksheets, you will also need to practice continuously on other practice paper. You can also download free worksheets on my website: writtenwordacademy.com/calligraphy-worksheets.

BASICS OF FAUX CALLIGRAPHY

Every now and then, you will want or need to write calligraphy on surfaces aside from paper—but because of the nib, true calligraphy is usually limited to very smooth, porous surfaces like paper. In order for you to apply calligraphy on various surfaces, you will need to re-create the look using other tools, such as brushes or markers.

Here are some guidelines for you to follow:

1 Whenever you're writing downward, thicken the line to mimic the look of a downstroke. If you're using a brush, apply slight pressure to the tip for the stroke to thicken. If you're using a marker, start with a monoline outline of the letter first, then shade in or redraw a line to the side of the stroke to thicken it.

2 When you're writing upward, create thin lines. If you're using a brush, write at the very tip of the brush. If you're using a marker, simply leave the upstrokes the way they are—no need to thicken the lines.

3 When you're transitioning from thick to thin lines, maintain the bottom transition point at four-fifths of the way down.

4 When you're transitioning from thin to thick lines, maintain the top transition point at the top of the stroke.

5 When you're writing horizontal strokes, maintain the same pressure so that the strokes are still thin. Do not thicken horizontal strokes.

6 For letters with overturns, make sure that you have square bottoms.

7 For letters with underturns, make sure that you have square tops.

Step 1: Write in monoline (even stroke throughout).

Step 2: Add the outline of the thickened stroke.

Step 3: Thicken the stroke.

Underturn

BOTTOM TRANSITION POINT

SQUARE TOP

UPSTROKE

Overturn

TOP TRANSITION POINT

SQUARE BOTTOM

PRACTICE EXERCISES

DOWNSTROKE

Press the nib down to create a square top and keep the pressure even and firm as you write downward.

Notes: At the bottom of the stroke, maintain the pressure and then lift up; don't drag the nib toward you. If you have a split stroke, shade the stroke through.

CURVE

Start with very light pressure. Once you hit the top of the stroke, increase pressure. About four-fifths of the way down, decrease pressure then go up.

Notes: Double-check that your angle 2 is correct, so that your thick stroke only manifests from the top of the curve to about four-fifths of the way down. The bottom of the stroke needs to be light.

UPSTROKE

Start at the bottom. With very light pressure, write a stroke going up until you hit the top.

Notes: Double-check your angle 2, so that your upstroke will not be thick. If you find your strokes squiggly, reduce pressure and check angle 1. Lower your angle 1 and try that. Don't overthink the strokes, and increase speed as needed.

PRACTICE EXERCISES

LEADING LINE

Leading lines are strokes that start a letter and should be written with little pressure. It is an upstroke.

Notes: If you find this stroke a bit squiggly, try to reduce pressure and increase speed.

OVAL

Start at the top right. At the top, increase pressure going downward, then at four-fifths of the way down, reduce pressure and go up.

Notes: Make sure that the bottom of your oval is light. That means you need to transition from the thick downstroke to a light stroke by the time you hit the bottom of the stroke.

UNDERTURN

Start with pressure at the very top of the stroke, so that you create a square top. About four-fifths of the way down, transition to a lighter stroke so that the bottom is light.

Notes: Don't slowly increase pressure for the downstroke; this will help you avoid a pointy top. Double-check your angle 2 if you find that the bottom of your stroke is heavy.

PRACTICE EXERCISES

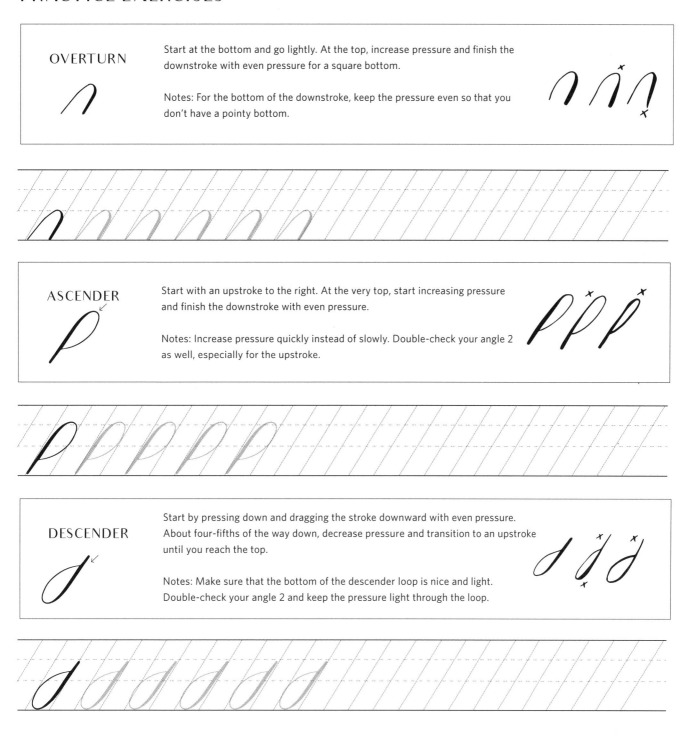

OVERTURN

Start at the bottom and go lightly. At the top, increase pressure and finish the downstroke with even pressure for a square bottom.

Notes: For the bottom of the downstroke, keep the pressure even so that you don't have a pointy bottom.

ASCENDER

Start with an upstroke to the right. At the very top, start increasing pressure and finish the downstroke with even pressure.

Notes: Increase pressure quickly instead of slowly. Double-check your angle 2 as well, especially for the upstroke.

DESCENDER

Start by pressing down and dragging the stroke downward with even pressure. About four-fifths of the way down, decrease pressure and transition to an upstroke until you reach the top.

Notes: Make sure that the bottom of the descender loop is nice and light. Double-check your angle 2 and keep the pressure light through the loop.

LOWERCASE LETTERS

In the lowercase letters section, the letters are not in alphabetical order; instead, they are in order of difficulty.

1. Start with light pressure for the leading line going up.
2. At the top, increase pressure going down to create a thick stroke.
3. About four-fifths of the way down, decrease pressure then go up for the flourish.
4. Create a dot by making a small ink circle, to ensure readability.
Notes: Keep the start of the *i* square. Keep the bottom of the *i* nice and light.

Gossamer

Lissome

1. Start with light pressure until you reach the top of the *c*.
2. At the top, turn and increase pressure going down to create a thick stroke.
3. About four-fifths of the way down, decrease pressure then go up for the flourish.
Notes: Keep the bottom of the *c* nice and light.

1. Start with light pressure for the leading line going up.
2. At the top, turn and increase pressure going down to create a thick stroke.
3. About four-fifths of the way down, decrease pressure then go up for the flourish.
4. Extend the flourish with light pressure.
Notes: Make the loop more horizontal than vertical. Keep the loop small, at maximum half of the letter.

1. Start with light pressure and slowly increase pressure going down.
2. About four-fifths of the way down, decrease pressure then go up and close the *a*.
3. At the top, increase pressure going down to create a thick stroke.
4. About four-fifths of the way down, decrease pressure then go up for the flourish.
Notes: Keep the top of the second downstroke square.

1. Start by pressing down so you create a thick stroke going down.
2. About four-fifths of the way down, decrease pressure then go up lightly.
3. At the top, exert light to medium pressure as you go down, because it's a flourish.
4. Extend the flourish with light pressure.
Notes: Practice the *o* shape diligently with a pencil. The first downstroke of the *o* should be the thickest; the subsequent downstrokes should be kept light.

1. Start with light pressure for the leading line going up.
2. At the top, turn and slowly increase pressure going down.
3. Stop at the corner, then continue the downstroke with pressure.
4. About four-fifths of the way down, go up and end the flourish with light pressure.
Notes: The first peak should be the highest point; it helps maintain the slant. Keep the corner of the *r* nice and light. If in doubt, reduce the pressure first to preserve shape.

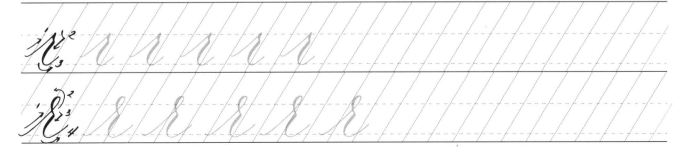

1. Start with light pressure for the leading line going up.
2. At the top, turn and increase pressure going down to create a thick stroke.
3. End with pressure for a thick stroke, then go up with light pressure.
4. At the top, turn and increase pressure going down to create a thick stroke.
5. About three-fourths of the way down, go up lightly then come back down again with pressure.
6. End with light pressure for the flourish.

1. Start with light pressure for the leading line going up.
2. At the top, turn and increase pressure going down to create a thick stroke.
3. End with pressure for a thick stroke, then with light pressure go up.
4. At the top, increase pressure going down to create a thick stroke.
5. About four-fifths of the way down, decrease pressure and go up for a flourish.
Notes: Keep the bottom of the first step square.

1. Start with light pressure for the leading line going up.
2. At the top, turn and slowly increase pressure going down to create a thick stroke.
3. About four-fifths of the way down, decrease pressure and create a loop.
4. For the loop, keep the pressure light.
5. Finish the flourish with light pressure.
Notes: Maintain a slow increase in pressure at both transitions.

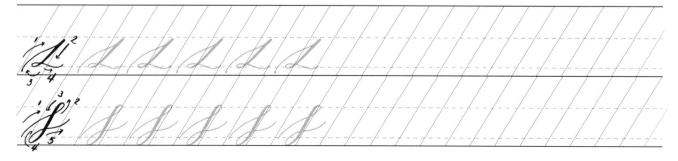

1. Start with light pressure for the leading line going up.
2. At the top, increase pressure going down to create a thick stroke.
3. About four-fifths of the way down, decrease pressure until the bottom and go up.
4. At the top, increase pressure going down to create a thick stroke.
5. About four-fifths of the way down, decrease pressure and go up lightly through the flourish.
Notes: Keep the tops of the downstrokes square.

1. Start with light pressure for the leading line going up.
2. At the top, increase pressure going down to create a thick stroke.
3. End with a sharp corner, then go up with light pressure.
4. With little pressure, end with a flourish.
Notes: Keep the top of the downstroke square. The bottom of the v should be more pointed.

1. Start with light pressure for the leading line going up.
2. At the top, increase pressure going down to create a thick stroke.
3. At the bottom, go up with very light pressure, and then come down again.
4. You may decide to go lower for the second downstroke. Go up with light pressure.
5. End with a flourish with light pressure.
Notes: Keep the top of the downstrokes square and not pointed.

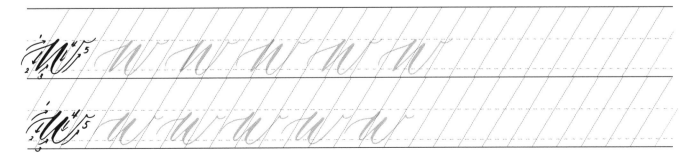

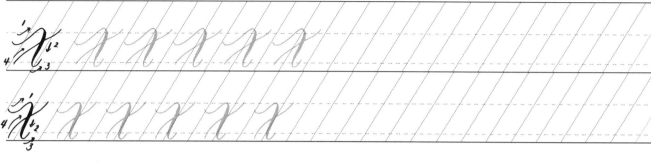

1. Start with light pressure until you reach the top.
2. Increase pressure going down, and once you hit the bottom go up lightly.
3. Create the intersection as an upstroke with light pressure.
4. End with a flourish with light pressure.
Notes: Form the x with one downstroke and one upstroke, and be gentle as you cross the downstroke so that you don't drag ink across.

1. Start with light pressure with the leading line going up.
2. At the top, turn and increase pressure going down to create a thick stroke.
3. About four-fifths of the way down, decrease pressure.
4. Go up for a flourish with light pressure.
Notes: Take note of your bottom transition point and angle 2 when writing the letter *l*.

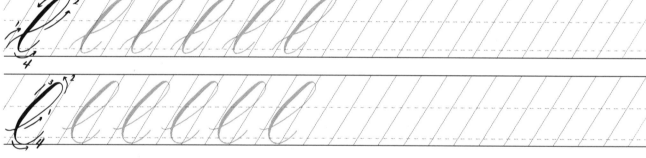

1. Start with light pressure for the leading line until you reach the top.
2. At the top, increase pressure going down to create a thick stroke.
3. About four-fifths of the way down, decrease pressure until you reach the bottom and go up.
4–5. Make a light horizontal curve with light pressure.
Notes: Keep your horizontal stroke light, and be cautious when you cross the downstroke.

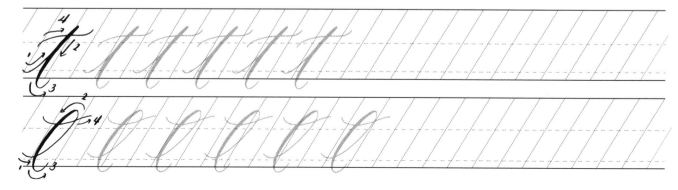

1. Start with light pressure, and turn and increase pressure going down.
2. Keep the pressure light at the bottom, then go up and close the gap to make an *o*.
3. Keep going up to the right and make an ascender (the upper loop).
4. At the top, turn and increase pressure going down to create a thick stroke.
5. About four-fifths of the way down, decrease pressure and go up for the flourish.
Notes: Make sure you complete the oval shape before starting the ascender.

1. Start with light pressure for the ascender (the upper loop). Large loops look better.
2. At the top, turn and slowly increase pressure going down.
3–4. Maintain the pressure and end with pressure for a thick stroke.
5. Go up with light pressure. At the top, slowly increase pressure coming down.
6. About four-fifths of the way down, decrease pressure and make a loop.
7. Extend the flourish with light pressure.

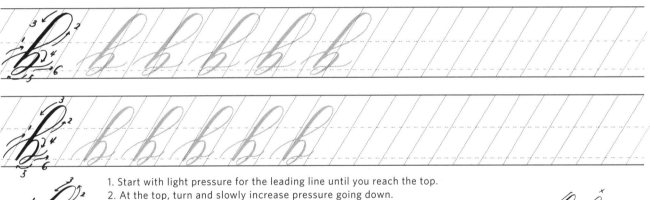

1. Start with light pressure for the leading line until you reach the top.
2. At the top, turn and slowly increase pressure going down.
3. Drag the pressure all the way down past the midline of the letter.
4. About four-fifths of the way down, decrease pressure until you reach the bottom and go up.
5–6. Make a loop with light pressure. End the flourish with light pressure.
Notes: Double-check your angle 2 for the main downstroke of the letter *f* and keep the bottom light.

1. Start with light pressure for the ascender (the upper loop) with the leading line going up.
2. At the top, turn and increase pressure going down.
3. Maintain the pressure and end with pressure for a thick stroke.
4. Go up with light pressure and come down with medium pressure.
5. About four-fifths of the way down, decrease pressure and go up for the flourish.
Notes: Keep the bottom of the *h* square and not pointy.

1. Start with light pressure for the ascender (the upper loop) with the leading line going up.
2. At the top, turn and increase pressure going down.
3. Maintain the pressure and end with pressure for a thick stroke.
4. Go up and close the loop with light pressure.
5. Go down with medium pressure then go up for the flourish with light pressure.
Notes: Keep the bottom right portion of the *k* small, just as high as the letter *a*.

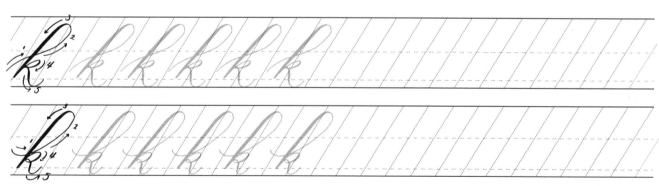

1. Start with light pressure and slowly increase pressure going down.
2. About four-fifths of the way down, decrease pressure and go up and close the *o* shape.
3. At the top, press down to create a thick stroke, and maintain pressure to create a descender.
4. About four-fifths of the way down, decrease pressure until you reach the bottom and go up.
5–6. Close the loop and make the intersection and flourish with light pressure.
Notes: Finish the oval shape of the *g* first before continuing with the downstroke. Ensure the descender starts with a square top.

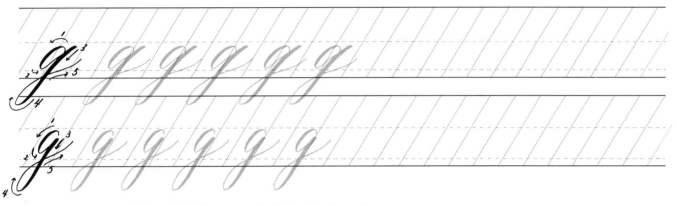

1. Start with light pressure for the leading line going up.
2. At the top, increase pressure for a thick stroke for the descender (the lower loop).
3. About four-fifths of the way down, decrease pressure until you reach the bottom and go up.
4. Close the loop and make the intersection with light pressure.
5. End the flourish with light pressure.
6. Create a dot by making a small ink circle to ensure readability.
Notes: Keep the top of the downstroke square and not pointy.

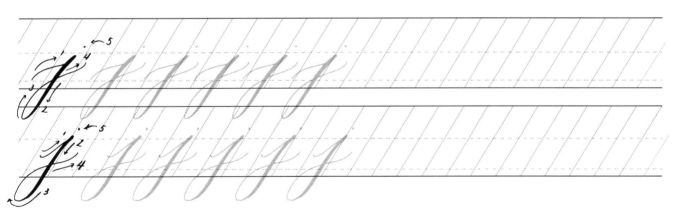

1. Start with making a *j* shape, with a leading line with light pressure going up.
2. At the top, increase pressure going down for a thick stroke for the descender loop.
3. About four-fifths of the way down, decrease pressure until you reach the bottom and go up.
4. Start again at the top with increasing pressure.
5. As you approach the bottom, decrease pressure and make a loop.
6. End the flourish with light pressure.

Notes: Break down the *p* into 3 parts: the letter *j*, an oval and a loop. This will help the overall shape of the letter. Make sure that the descender starts with a square top.

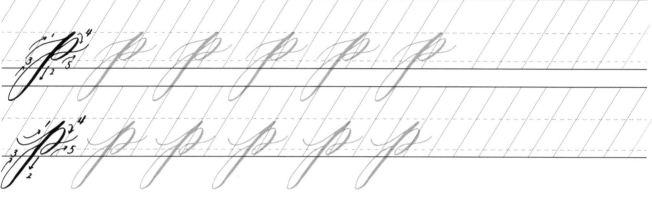

1. Start with light pressure and slowly increase pressure going down.
2. About four-fifths of the way down, decrease pressure and go up and close the *o* shape.
3. At the top, increase pressure to create a thick stroke for the descender (the lower loop).
4. About four-fifths of the way down, decrease pressure until you reach the bottom and go up.
5. End with a loop or a flourish with light pressure.

Notes: Finish the *o* shape first before making the downstroke. Keep the top of the descender square.

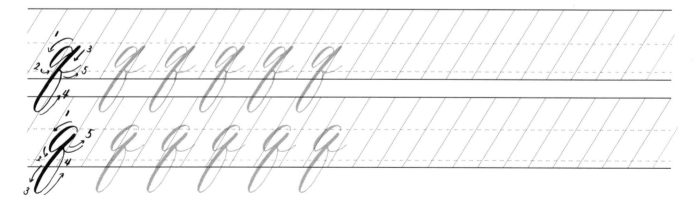

1. Start with making a *u* shape, with a leading line with light pressure going up.
2. Increase pressure going down. At four-fifths of the way down, decrease pressure and go up.
3. At the top, increase pressure to create a thick stroke for the descender (the lower loop).
4. About four-fifths of the way down, decrease pressure until you reach the bottom and go up.
5. Make the intersection and flourish with light pressure.

Notes: Keep the tops of the *y* square by pressing down evenly as you write these parts.

1. Start with light pressure for the leading line going up.
2. At the top, turn and slowly increase pressure going down.
3. Create a corner and slowly increase pressure again for the descender (the lower loop).
4. About four-fifths of the way down, lighten up the pressure until you reach the bottom and go up.
5. Make the intersection and flourish with light pressure.

Notes: The height of the letter *z* is a bit higher than the letter *a*, similar to the letter *f*.

UPPERCASE LETTERS

1. Start with a small downstroke, then go up with light pressure until you reach the top.
2. At the top, increase pressure going down to create a thick stroke.
3. About four-fifths of the way down, decrease pressure until you reach the bottom and go up.
4. Make a horizontal intersection with light pressure.

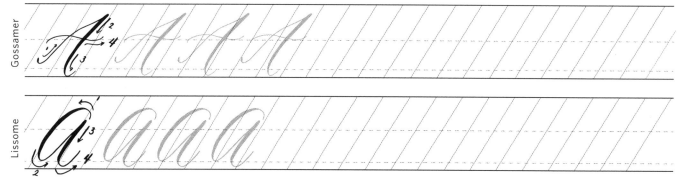

Gossamer

Lissome

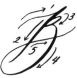

1. Start with light pressure for the leading line going up until you get to the top.
2. Increase pressure going down for a thick stroke. Taper off as you get to the bottom.
3. Start again at the top and close the shape with medium pressure.
4. Slowly increase pressure going down for the second shape. About four-fifths of the way down, decrease pressure.
5. End the flourish with light pressure.

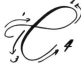

1. Start with light pressure for the leading line going up.
2. At the top, slowly increase pressure going down.
3. About four-fifths of the way down, decrease pressure so the bottom is nice and light.
4. End the flourish with light pressure.

1. Start with slowly increasing pressure and maintaining it through the downstroke.
2. About four-fifths of the way down, decrease pressure so the loop is light.
3. Keep the pressure light as you lead the upstroke up and around the letter.
4. Once you hit the top, slowly increase pressure going down.
5. About four-fifths of the way down, decrease pressure as you end the flourish.

1. Start with light pressure for the leading line going up.
2. At the top, go down and slowly increase pressure until you reach the corner.
3. At the corner, go down again and slowly increase pressure.
4. About four-fifths of the way down, decrease pressure then go up for a flourish.

1. Start with light pressure for the leading line going up.
2. At the top, slowly increase pressure going down.
3. About four-fifths of the way down, decrease pressure then go up for a flourish.
4. Make a horizontal stroke with light pressure, especially as you cross the downstroke.

1. Start with light pressure for the leading line going up.
2. At the top, slowly increase pressure going down.
3. About four-fifths of the way down, decrease pressure and go up.
4. At the top, increase pressure for a thick stroke and maintain pressure going down.
5. About four-fifths of the way down, decrease pressure and go up.
6. Finish the flourish with light pressure.

1. Start with light pressure for the leading line going up.
2. Increase pressure going down to create a thick stroke, then decrease pressure about four-fifths of the way down and go up for a flourish.
3. Start again to the right of the first downstroke and repeat step 2.
4. Make a horizontal stroke with light pressure, especially as you cross the downstrokes.

1. Start with light pressure going up through the curve until you reach the top.
2. At the top, increase pressure going down to create a thick stroke. About four-fifths of the way down, decrease pressure.
3. End with a flourish with light pressure.

1. Start with light pressure going up through the curve until you reach the top.
2. At the top, increase pressure going down to create a thick stroke.
3. About four-fifths of the way down, decrease pressure. Go up and make a loop.
4. Keep the pressure light as you make the intersections and finish the flourish.

1. Start with light pressure for the leading line going up.
2. At the top, increase pressure going down to create a thick stroke, then decrease pressure four-fifths of the way down. Go up with light pressure.
3. Start at the top with pressure, then decrease pressure as you get to the intersection.
4. Make a small loop with light pressure.
5. Go down with pressure, then decrease pressure toward the end.

1–2. Start with light pressure for the leading line going up.
3. At the top, slowly increase pressure going down. About four-fifths of the way down, decrease pressure. You may decide to make a loop or not at the corner.
4. With light pressure, make a downward flourish to complete the letter.

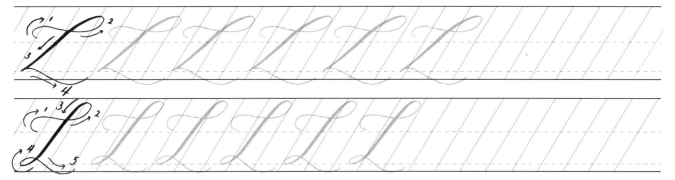

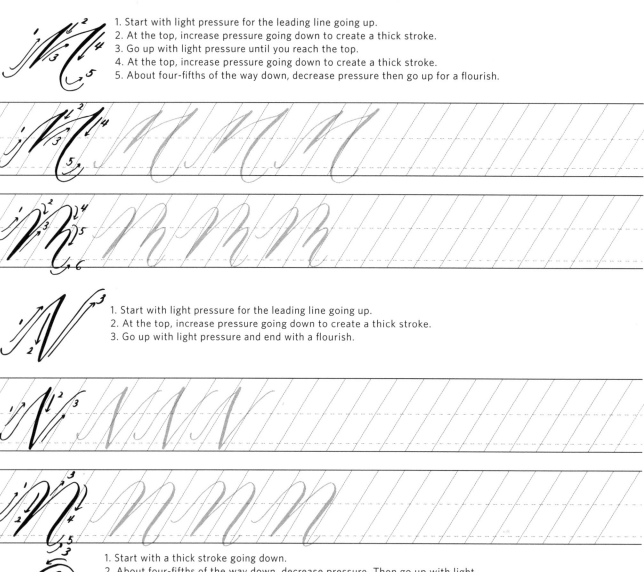

1. Start with light pressure for the leading line going up.
2. At the top, increase pressure going down to create a thick stroke.
3. Go up with light pressure until you reach the top.
4. At the top, increase pressure going down to create a thick stroke.
5. About four-fifths of the way down, decrease pressure then go up for a flourish.

1. Start with light pressure for the leading line going up.
2. At the top, increase pressure going down to create a thick stroke.
3. Go up with light pressure and end with a flourish.

1. Start with a thick stroke going down.
2. About four-fifths of the way down, decrease pressure. Then go up with light pressure, up and around the letter.
3. At the top, slowly increase pressure going down.
4. About four-fifths of the way down, decrease pressure and end with a flourish.

1. Start with light pressure for the leading line going up.
2. Increase pressure going down for a thick stroke and taper off at the bottom.
3. Start again at the top with little pressure, then slowly increase pressure.
4. About four-fifths of the way down, decrease pressure and make the loop.
5. Complete the loop with little pressure.

1. Start with a thick stroke going down.
2. About four-fifths of the way down, decrease pressure. Then go up with light pressure, up and around the letter.
3. At the top, slowly increase pressure going down.
4. About four-fifths of the way down, decrease pressure and end with a flourish.
5. Make a light horizontal stroke for the tail.

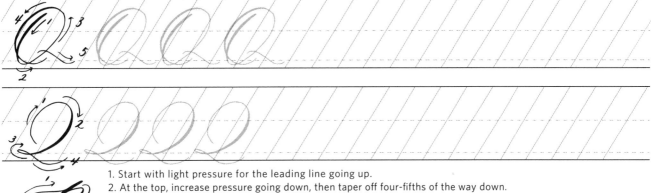

1. Start with light pressure for the leading line going up.
2. At the top, increase pressure going down, then taper off four-fifths of the way down.
3. Start again at the top with little pressure, then increase pressure going down.
4. About four-fifths of the way down, decrease pressure and make the loop.
5. Make a downstroke with medium pressure, then decrease pressure toward the end.

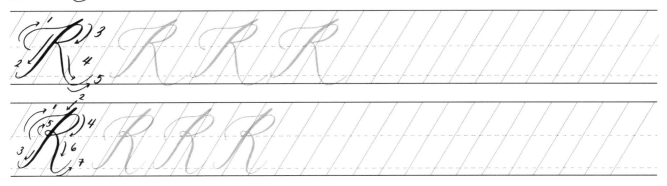

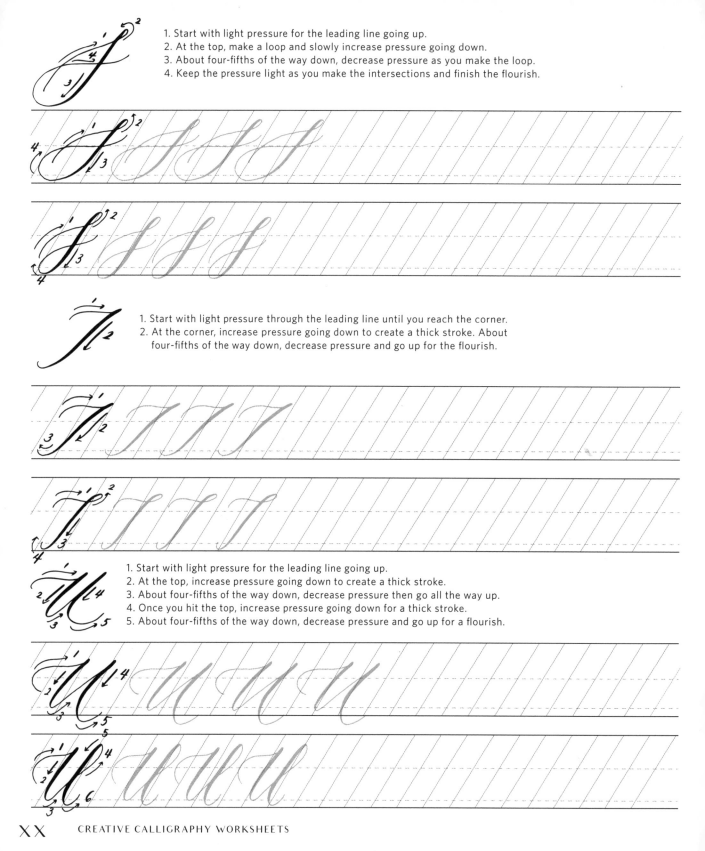

1. Start with light pressure for the leading line going up.
2. At the top, make a loop and slowly increase pressure going down.
3. About four-fifths of the way down, decrease pressure as you make the loop.
4. Keep the pressure light as you make the intersections and finish the flourish.

1. Start with light pressure through the leading line until you reach the corner.
2. At the corner, increase pressure going down to create a thick stroke. About four-fifths of the way down, decrease pressure and go up for the flourish.

1. Start with light pressure for the leading line going up.
2. At the top, increase pressure going down to create a thick stroke.
3. About four-fifths of the way down, decrease pressure then go all the way up.
4. Once you hit the top, increase pressure going down for a thick stroke.
5. About four-fifths of the way down, decrease pressure and go up for a flourish.

1. Start with light pressure for the leading line going up.
2. Once you hit the top, increase pressure going down to create a thick stroke until you reach the bottom.
3. At the bottom, go up with light pressure and finish with a flourish.

1. Start with light pressure for the leading line going up.
2. At the top, increase pressure going down for a thick stroke until you reach the bottom.
3. With light pressure, make an upstroke until about three-fourths or four-fifths of the way up.
4. Increase pressure going down for a thick stroke until you reach the bottom.
5. Go up with light pressure and finish with a flourish.

1. Start with light pressure for the leading line going up.
2. At the top, slowly increase pressure going down to create a thick stroke.
3. About four-fifths of the way down, decrease pressure and go up for a flourish.
4. Create a curved upstroke with light pressure.

1. Start with light pressure for the leading line going up.
2. At the top, increase pressure going down to create a thick stroke.
3. About four-fifths of the way down, decrease pressure and go all the way up.
4. At the top, increase pressure going down to create a thick stroke.
5. About four-fifths of the way down, decrease pressure and create a loop.
6. Close the loop with light pressure.

1. Start with light pressure for the leading line going up.
2. At the top, slowly increase pressure going down then decrease pressure as you approach the corner.
3. At the corner, slowly increase pressure going down.
4. About four-fifths of the way down, decrease pressure and close the loop.

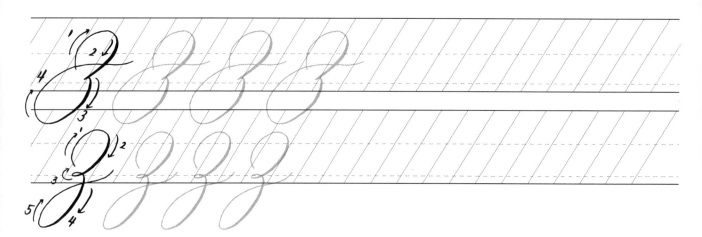

Connecting Lowercase to Lowercase: Write Your Name

Narrow and tidy, with letters on the baseline.

rachel

Floating letters with ample space between letters.

rachel

Tight space between letters with slight lifts.

rachel

Varied heights.

rachel

Narrow and tidy, with letters on the baseline.

michelle

Floating letters with ample space between letters.

michelle

Small with very little space between letters.

michelle

Letters with varied heights.

michelle

Connecting Uppercase Letters to Lowercase Letters

Michelle

Michelle

Natalie

Anna

Alexander

Emma

Ethan

Vincent

gine hovering on paper, from the bottom to top. Do this in medium speed

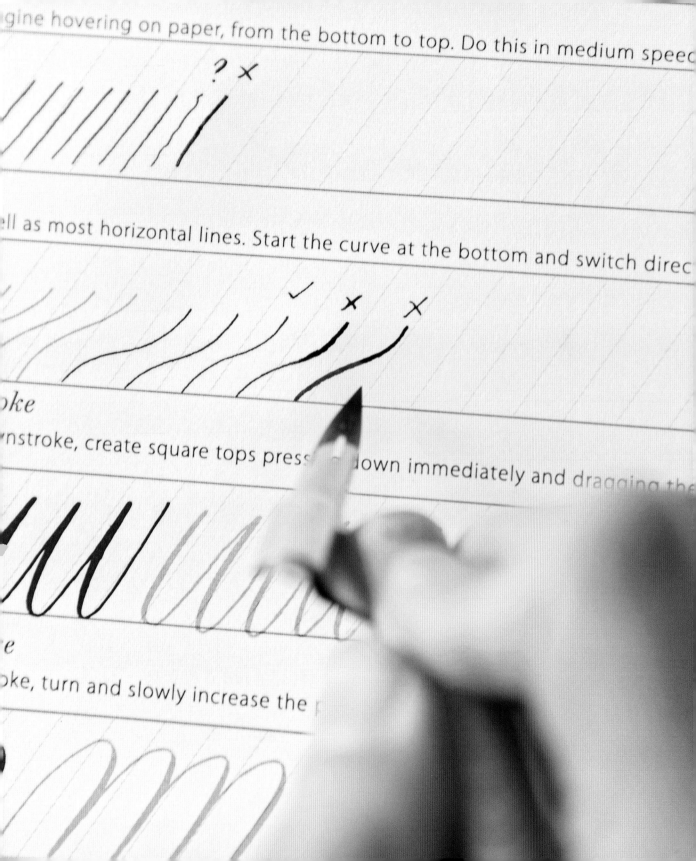

ell as most horizontal lines. Start the curve at the bottom and switch direc

oke

nstroke, create square tops press down immediately and dragging the

e

oke, turn and slowly increase the

Projects

Once you have completed the practice plan, you can start to create some calligraphy projects with your newfound skills! Each project will have detailed instructions, but the calligraphy style is open. I have also created templates that you can download from my website (see Resources on page 170) to use as reference and inspiration as you continue to improve your calligraphy writing. The templates will have different calligraphy styles, such as Gossamer and Lissome, which you learned in the worksheets.

Creative Cards for Every Occasion

One of the reasons I got into calligraphy was because I wanted to make personalized, handmade cards for my family and friends. Cards are a great place to start for creating projects with calligraphy. Here are a few lessons I've learned along the way:

- Start with writing a word or two in calligraphy, such as the person's name. This immediately makes the card extra special, and it enhances the look and elevates even the most ordinary card. The entire card doesn't need to be written in calligraphy.

- Once you get comfortable with calligraphy, address the envelope in calligraphy. Start with the name. Then, when you feel like you're ready, write the address in calligraphy as well. We'll be going through details on how to address envelopes at the end of this chapter (see page 55).

- Incorporate other media, such as watercolor, illustrations and gold leaf, to complete the look. We will be using some of these techniques in the projects in this chapter.

- Research, research, research! Pinterest is a great place to search for quotes and card wording if you're not sure what to say.

Over time, as your calligraphy improves, your cards will get better as well. As I said before, practice makes progress! In the next few pages, you will learn how to incorporate calligraphy and some basic art skills into creating memorable cards for multiple occasions. Hopefully, this chapter gives you some ideas—I cannot wait to see what you do!

A NOTE ON CARDS

In the next few chapters, there will be some projects that require some scoring. Scoring is the process of creating a crease so that you can fold thicker sheets, such as cardstock, easily. I like scoring my paper so that I can fold a card cleanly. If you've tried to fold a thick card in half without scoring, you'll know what I mean—it creates a messy fold that may not be straight, or it may tear the paper. Scoring guides the fold and reduces the chance of tearing the paper. In order to score a card, you can use either of the following:

Scoring device: Most office supply stores have these. You simply need to insert the paper and drag the scorer down.

Scoring knife and ruler: A scoring knife is a blunt knife that you can use to create the crease on your paper, and you will need the ruler to make sure the crease is straight.

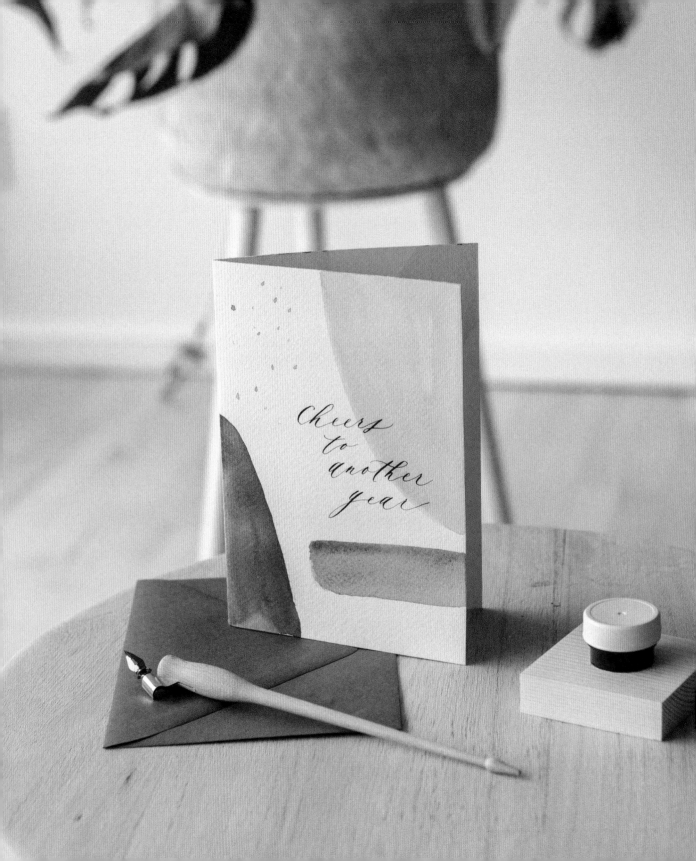

EARTH-TONED WATERCOLOR
BIRTHDAY CARD

There's something about receiving a handmade birthday card in the mail that makes it oh so special. This tutorial is going to incorporate your recipient's favorite color palette (or perhaps the colors that represent the season their birthday is in) and calligraphy to make their birthday card extra beautiful. If this is your first time working with watercolors or you're a bit intimidated by them, don't worry! I have outlined step-by-step instructions on how to mix the colors and to make the strokes that you'll need to create this look. For the calligraphy, you'll use a pencil to outline the letters, so that you will need to only trace over the letters. It can be a bit scary to write on a "final project" card, but tracing over pencil marks actually reduces the pressure a bit, and you can focus on your writing. And don't worry—your recipient is definitely going to see the love that you've poured out onto this card!

+ Round or flat paintbrushes (size 00 and size 14 or similar)

+ Container of water

+ Clean square dish or palette

+ Watercolor palette that includes white, red, yellow and brown (Winsor & Newton Cotman Water Colours palette or similar)

+ 10 x 7-inch (25.4 x 17.8-cm) cold press watercolor paper, cut to size and scored in the middle

+ Facial tissue (optional)

+ Ruler

+ Light pencil (such as a 9H)

+ Calligraphy pen (such as the Written Word Dual Purpose Calligraphy Pen)

+ Nib (such as a Nikko G)

+ Ink color of choice

+ Scrap watercolor paper

+ Envelope for card

How To

1

2

3

4

5a

5b

6

7

8

Tips and Tricks

+ Use a scoring device or a scoring knife and ruler to create a crease in the middle of your paper, so that the card will fold into a 5 x 7–inch (12.7 x 17.8–cm) card.

INSTRUCTIONS

1 Wet your paintbrushes, especially if they are new, in the container of water. On the clean dish, create paint by mixing colors with the size 14 paintbrush. You will need to create four colors. Use the four corners of the dish. Wet your brush, dab your brush onto the color on the watercolor palette then dispense the paint onto the dish. Wet your brush again. Repeat the process until you have about 1 teaspoon of paint per color. (Note: You will need to adjust as the color changes. If the color doesn't look right, that's okay. Start by adding more water and then add the paint; if it's still not the right color, start again.) Make the following 4 colors:

Pale Blush: Mix lots of white and the smallest dabs of red and yellow.

Dusty Rose: Mix some white and the smallest dabs of red and yellow.

Terra-Cotta: Mix together some red and yellow with a bit of brown.

Neutral Brown: Take a bit of the Terra-Cotta and add some brown and yellow.

2 Once the paints are prepped, start with the lightest color first. On the scored watercolor paper, paint two or three shapes onto the card with a bit of the Pale Blush—you can try ovals, circles, squares, lines or half of these shapes. Make sure that there is lots of space between these shapes, so that you can add the other colors without two shapes of the same color next to each other.

3 Add Dusty Rose paint to the card, this time in another spot and in two varying shapes and sizes.

4 Add the Terra-Cotta paint to the card. If in doubt, just put it in one spot first—if there's more room in another spot, add another shape.

5 Add the Neutral Brown paint to the card. This color may appear the least in your card. You may also decide to add some "spattering" of paint, which you can achieve by using the size 00 brush.

6 Wait for the paint to dry. You'll know that the paint is dry by taking a peek from the side of the paper. If there is still water drying on the paper, it needs more time. You can also lightly tap the artwork with a piece of tissue if desired. Paint additional color splotches as needed.

7 Lay out the greeting for the card in calligraphy using the ruler and light pencil. Use the ruler to measure the margins on the side of the card first, then write the greeting on the card in pencil as if you were writing in calligraphy. You will need to make sure that your writing is at the height and width of calligraphy, and not like your day-to-day handwriting.

8 Fit the calligraphy pen with the nib. To ensure that the ink of choice is flowing correctly, test the ink flow on the scrap watercolor paper. Write two to three strokes first after you dip the nib into the ink. If it's flowing properly, you can continue; if it's not flowing, add some water. Using the pencil layout as reference, write the greeting "Happy Birthday" in calligraphy on the front of the card using the calligraphy pen.

9 Wait for the ink to dry, erase the pencil marks and pair the card with an envelope.

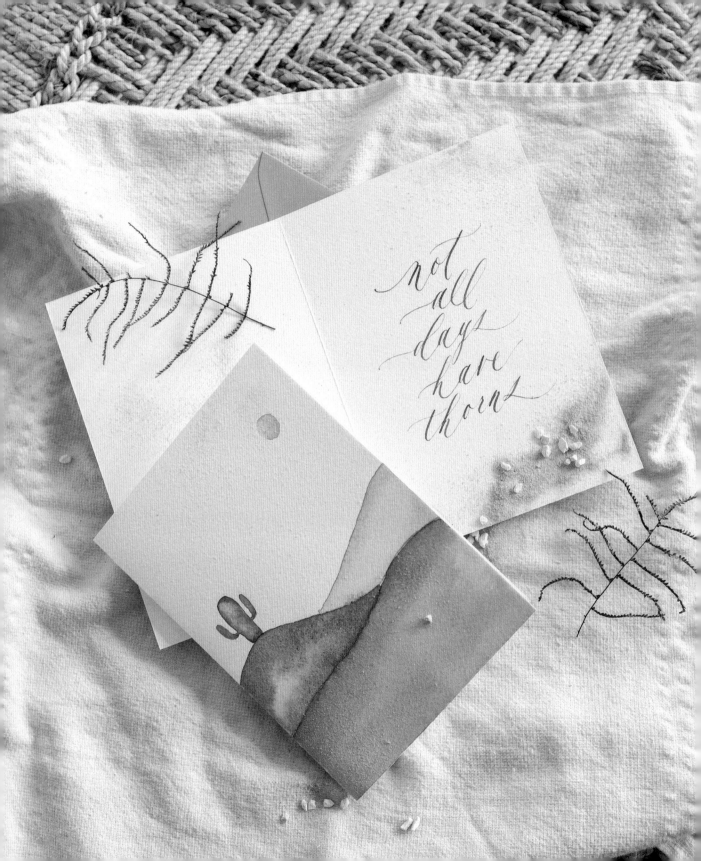

DESERT-INSPIRED GET WELL SOON CARD

Every now and then, a friend or family member goes through a tough time, and a handwritten note expressing your presence and encouragement can be very helpful. Especially when it's written in calligraphy. Calligraphy, invites us to slow down and create things purposefully. You will be able to share your compassion and intention through calligraphy, coupled with a beautiful watercolor illustration of the desert.

For this project, we are going to paint some sand dunes and a cactus. You're also going to learn how to use watercolor paint as ink. There's something magical about watercolor, and when you use it as ink, it creates gorgeous, memorable gradients. I promise that the resulting artwork is going to be beautiful and that your recipient is going to love it.

Supplies

+ Round watercolor paintbrushes (size 2 and size 14 or similar)

+ 2 containers of clean water (1 for cold tones and 1 for warm tones)

+ Clean square dish or palette

+ Watercolor palette that includes white, yellow, brown, green and black (Winsor & Newton Cotman Water Colours palette or similar)

+ Light pencil (such as a 9H)

+ Eraser

+ 10 x 7-inch (25.4 x 17.8-cm) cold press watercolor paper, scored in half

+ Calligraphy pen

+ Nib (such as a Nikko G)

+ Scrap watercolor paper

+ Envelope for the card

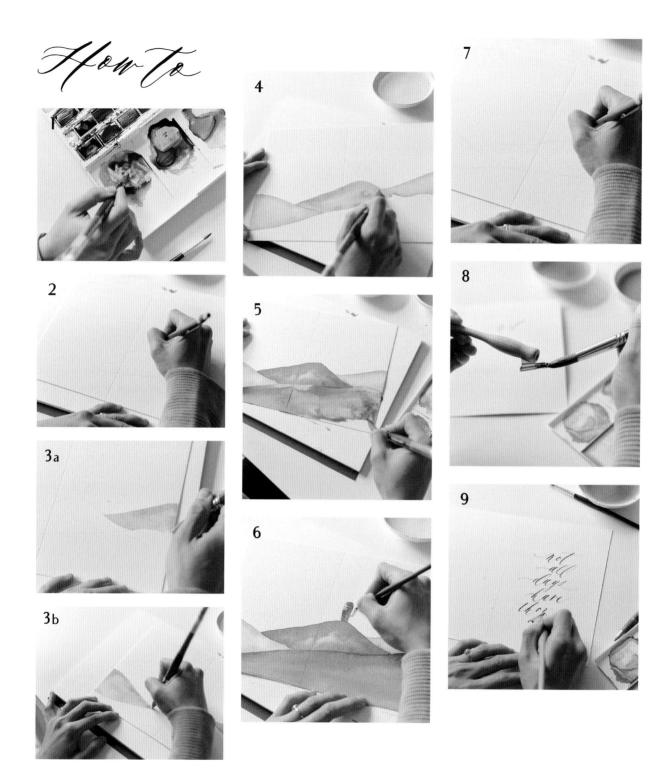

INSTRUCTIONS

1 Wet your paintbrushes, especially if they are new, in one of the containers of water. On the clean dish, create paint by mixing colors with the size 14 paintbrush. You will need to create 4 colors. Use the 4 corners of the dish. Wet your brush, dab your brush onto the color on the watercolor palette then dispense the paint onto the dish. Wet your brush again. Repeat the process until you have about 1 teaspoon of paint per color. (Note: You will need to adjust as the color changes. If the color doesn't look right, that's okay. Start by adding more water and then add the paint; if it's still not the right color, start again.) Make the following 4 colors:

Pale Beige: Mix lots of white and the smallest dabs of yellow and brown.

Taupe: Mix some white and the smallest dab of brown.

Neutral Brown: Take a bit of Taupe and add more brown to it.

Sage Green: Mix green with a bit of black.

2 Using a light pencil, draw the sand dunes on the watercolor paper. Make your sketches light and clean because you'll be painting various layers of color on them, and it is hard to erase pencil sketches once you put paint on them. Use an eraser if the lines are not clean.

3 Dab your brush in one of the containers of water, which will be used for cold tones. Dab the wet brush onto the Pale Beige, and then paint over the sketches of sand dunes. The paper will be really wet, and that's okay. It's part of the process. Add a bit more Pale Beige to the edges of the paper, so that when it dries, the dunes will have some darker portions. Repeat this process on another section that does not touch your Pale Beige section. Wait until the paint is completely dry before proceeding.

4 Using the same technique described in step 3, paint a section between two Pale Beige dunes with Taupe. Wait until the paint is completely dry before proceeding.

5 Paint the lower section with Neutral Brown. Wait until the paint is completely dry before proceeding.

6 Use the size 2 brush and the Sage Green paint to paint the simple three-stem cactus. Start off with a wet silhouette of a cactus. Paint the larger middle stem first, then add two arms with a wet brush. Next, dab your brush on the paint, then dab the corners of the silhouette to add some shadows and textures to your illustration. Let the paint dry completely before adding additional details such as spikes or stripes.

7 On the inside of the card, use a light pencil to draft the greeting for calligraphy. Make sure that you write as if you were writing the final artwork in calligraphy, making sure the wording is larger and wider than your usual handwriting.

8 Fit the calligraphy pen with the nib. Use the Neutral Brown or Sage Green paint as ink, so that the greeting will be cohesive with the rest of the card. Brush the paint onto the nib to use it as ink. You may need to add a bit more pigment to your paint to make sure it is dark enough to be read. Test the paint on a scrap piece of watercolor paper before you continue writing on your card.

9 Write the greeting "Not all days have thorns" on the inside of the card.

Wait for the card to dry completely. Pair the card with an envelope to complete the look.

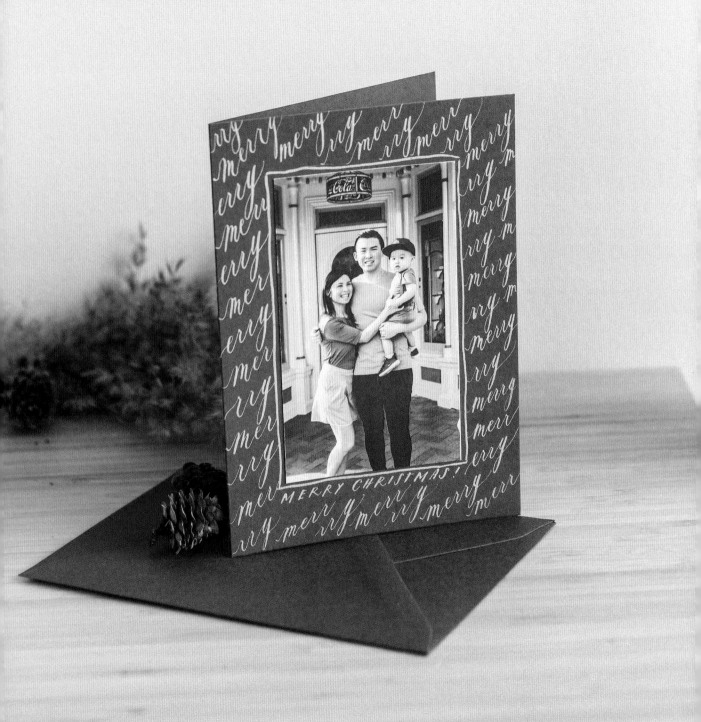

FESTIVE GOLD HOLIDAY CARD

Growing up, I didn't quite understand why my parents would ask us to pose for a family photo every year or why we would receive countless holiday cards with photos during the holidays (or why they would live on our fridge door for most of the year)—until I had my own family. Now I finally understand! There's something so special about seeing how your family and friends are doing in a tangible format, wherever they are in the world. I've always taken it on myself to design some handmade cards every year during the holidays, adding a picture or two of our little family and writing a short update to share our gratitude for the year that has passed. There's also something touching about sending a greeting to family and friends who don't have access to social media or aren't as well versed with technology. Believe me, this handmade touch will go a long way.

In this project, you're going to learn how to draw illustrations with a calligraphy pen, which is actually very easy. The beauty of using a calligraphy pen to illustrate is that you can create shading and texture as you draw. As you add slight pressure to drawing the leaves, your nib will automatically create thin and thick lines, which will result in a memorable look. This is also your first project writing with gold ink! Gold ink elevates the look of any handmade card, and it has a festive feel. And it is easy as long as you have the right ink. I've searched high and low for the right shade of gold, and Dr. Ph. Martin's Iridescent Copper Plate Gold ink is my favorite one straight from the bottle.

For this tutorial, I've created two options: One will be written with repeated greetings. The second will boast some illustration. I'm going to share a few tips and tricks to create a beautiful, meaningful touch from you to your loved ones!

+ Double-sided tape

+ 2 (3 x 5-inch [7.6 x 12.7-cm]) photos

+ 2 sheets colored cardstock (such as Gmund Sepia for a deep rust or Gmund Racing Green for a deep hunter green), each cut into a 10 x 7-inch (25.4 x 17.8-cm) rectangle and scored in half

+ Calligraphy pen

+ Nib (such as a Brause Steno Blue Pumpkin)

+ Dr. Ph. Martin's Iridescent Copper Plate Gold ink

+ Ruler (optional)

+ Envelope for the card

How To

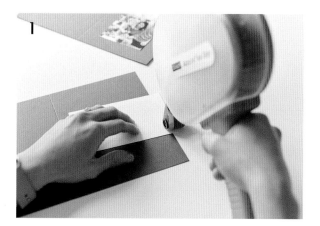

1

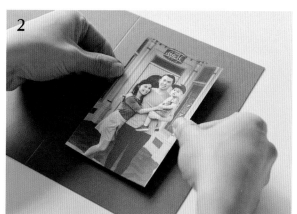

2

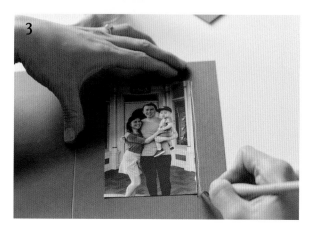

3

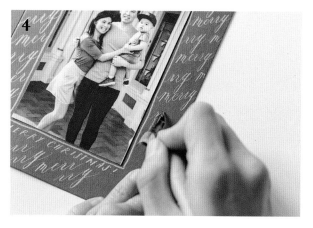

4

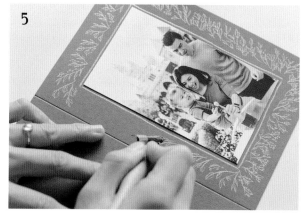

5

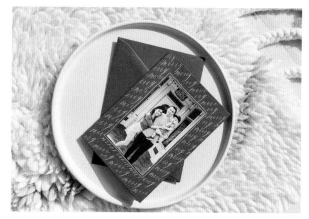

Tips and Tricks

+ At the bottom of the border, you can add your greeting, the date or both. Wait until the ink is completely dry before starting the pattern process.

INSTRUCTIONS

1 Add double-sided tape to the back of the photos.

2 Center a photo on the front of each of the cards.

3 Fit the calligraphy pen with the nib. In the gold ink, draw a border around the photo. Don't worry if it's not 100 percent straight or even—imperfection is part of the handmade look of this project. If you want the outline to be more exact, use a ruler to help guide the pen. Be careful to not let the ink touch the ruler, as it might cause it to smudge when you remove the ruler.

4 To make a card with repeated greetings, starting from the top left corner of the card, write the word "merry" over and over again at a 45-degree angle so that it creates a pattern.

5 To make a card with illustration, starting from the top left corner of the card, draw simple leaves and branches, holly branches with berries or pine needles and dots and repeat this pattern. Pair the card with an envelope to complete the look.

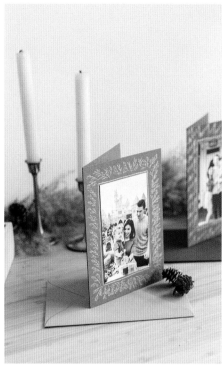

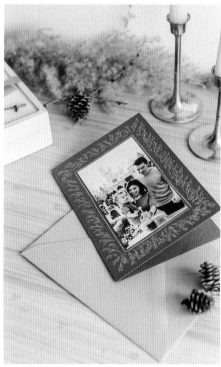

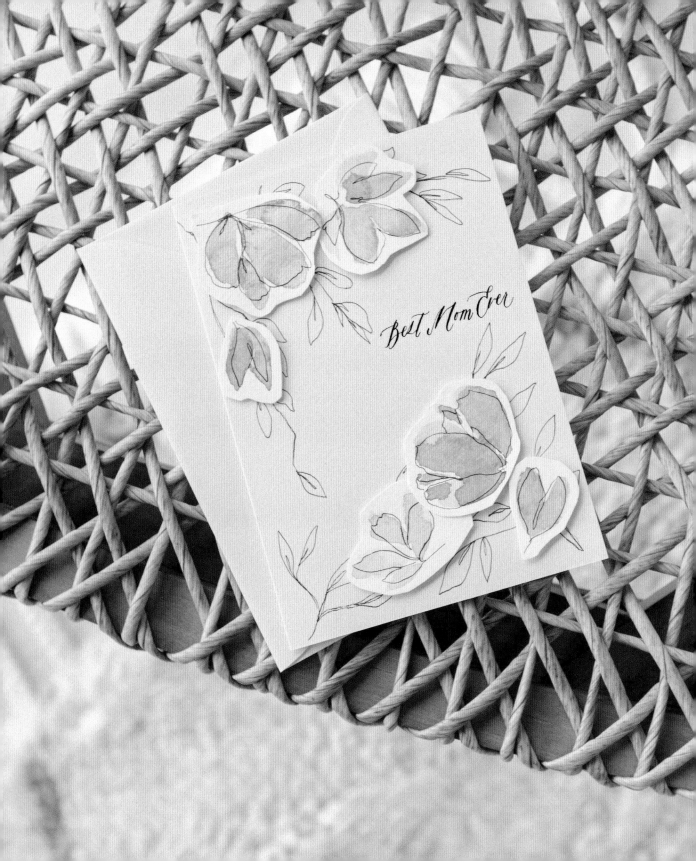

SPRING-INSPIRED FLORAL MOTHER'S DAY CARD

It's not surprising that Mother's Day is the busiest season for cards and flowers! I still remember crafting cards and projects all through my childhood, whether at school, at home or even at the mall, just for Mother's Day.

This little project is close to my heart because not too long ago, I became a mom myself. Now I understand how special it is to receive something your little one (and your not-so-little one) made, even though it's only one day a year. It means that they spent the time and effort, and poured love and meaning into creating something just for you—a little thank-you for the craziness you had to deal with all those years. In this card-making project, you're going to learn how to incorporate various skills to create a unique 3D card. You will learn how to paint simple watercolor flowers, how to illustrate flowers in a minimalist, modern style and how to create a 3D effect by adding some height to your card. Then you'll be using your new calligraphy skills to show your mom how much you care. For this card, I used the Gossamer calligraphy style, complemented by a peach floral motif. This creates an elegant effect your mom or mother figure will love.

+ Round brush (size 14 watercolor brush or similar)

+ Container of water

+ Clean dish

+ Watercolor palette that includes orange, red and white

+ Light pencil (such as a 9H)

+ Watercolor paper (Legion Stonehenge Aqua cold press or similar)

+ Sakura Pigma® Micron® pen (size 005 or 01 or similar monoline pigment pen)

+ Scissors

+ Cardstock (Vellum White Matte from Cards & Pockets or similar), cut into a 10 x 7-inch (25.4 x 17.8-cm) rectangle, scored in half and folded to make a 5 x 7-inch (12.7 x 17.8-cm) card

+ Calligraphy pen

+ Nib (such as a Hunt 101)

+ Best Bottle sumi ink, Moon Palace ink or sumi ink of choice

+ Eraser

+ Double-sided foam tape

+ Envelope for card

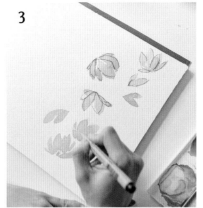

How to

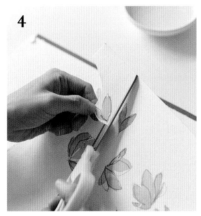

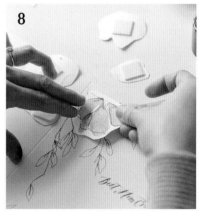

INSTRUCTIONS

1 Wet your brush in the container of water. On the clean dish, dab together a little orange paint, red paint and water to make a peach-pink paint. Create about 1 teaspoon of paint. If the color is too dark, add a bit of white to it as well.

 To create flowers, use a pencil to draw a 1-inch (2.5-cm) half circle on the watercolor paper. Fill the inside of the half circle with strokes of the peach paint: Create petals by starting in the middle of the half circle and pressing your brush down and toward the outside of the half circle, lifting your brush up as you finish the stroke. This will create a petal with a gradient. Repeat the process on the opposite end of the half circle. Vary your floral illustrations by creating two, three, four or five petals.

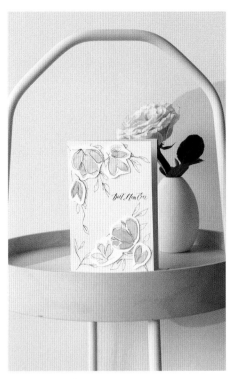

2 Repeat step 1 until you have created about eight flowers. Wait for about 30 minutes, until the paint is dry, before proceeding.

3 Now it's time to outline the flowers. The look we are going for is a bit loose and modern, so you don't need to outline the flowers exactly. Using the Sakura Pigma Micron pen, draw the outline about ⅓ inch (3 mm) off-center of the painted petals. Add some detail as needed. When possible, draw with a continual stroke, not lifting the pen off the paper as you outline each flower.

4 Using a pair of scissors, cut out the flowers with a ¼-inch (6-mm) margin all around them.

5 On the right side of the folded cardstock, use the Sakura Pigma Micron pen to draw branches bordering the card from the top and the bottom. If you need some inspiration, take a branch from a tree and observe how the leaves flow.

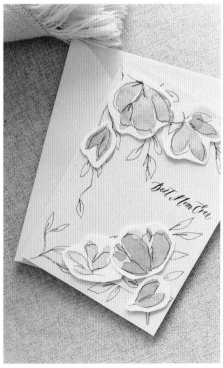

6 Use a pencil to outline the quote or greeting on the front of your card. Fit the calligraphy pen with the nib. Trace over the greeting with the sumi ink. Once the ink is completely dry, use an eraser to remove the pencil marks.

7 To create the 3D look of the card, put two layers of double-sided foam tape together and cut them into ½ x ½-inch (1.3 x 1.3-cm) squares. Remove the backing from one side of the double-sided tape and attach the squares to the flowers.

8 Prepare your layout by placing the flowers on the card. Once you are happy with how the design looks, remove the other side of the tape's backing and stick the flowers onto the card one at a time. I recommend having two different collections of flowers and grouping them in two opposing corners. This will help balance the overall look of the cards. Pair the card with an envelope.

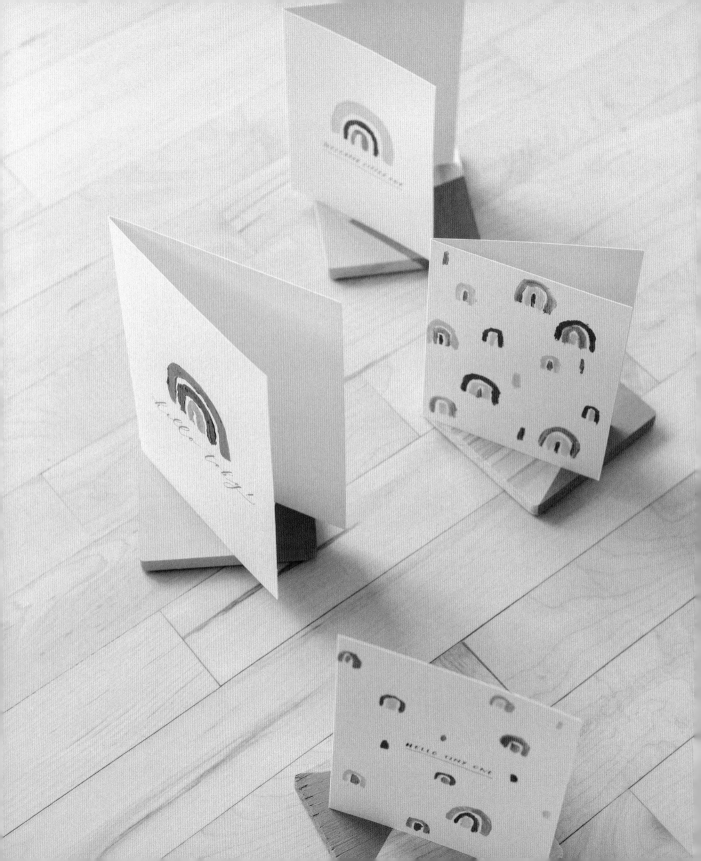

RAINBOW BABY WISHES CARD

Rainbows symbolize so many beautiful things. Rebirth. Life. Hope. Joy after suffering. Some babies are called rainbow babies, like a blessing after a stormy miscarriage, stillbirth or infant death. My little one was a rainbow baby as well. We were so blessed to know that he was coming after some tough times. The blessing of life after infertility struggles, miscarriage and sad seasons is surely something to be celebrated. Sending this little handmade card is so meaningful and thoughtful, and I'm sure your expecting friend will be touched. Adding the baby's name would make it all the more special!

In this project, you're going to learn how to incorporate acrylic paint with a gel medium. This unique technique will add a 3D effect to the strokes, which will give you a new way to paint other cards in the future. You'll also be learning how to mix acrylic paint to achieve the right color combinations. Finally, you'll finish the look with calligraphy using a pen, a nib and ink (or acrylic paint)!

Supplies

+ Gouache or acrylic paint (such as Schmincke or Grumbacher brands)

+ Palette

+ Spatula

+ Acrylic gel medium

+ Round paintbrushes (various sizes)

+ Watercolor paper or cardstock, cut into a 5½ x 8½-inch (14 x 21.6-cm) rectangle and scored in half

+ Container of water

+ Light pencil (such as a 9H)

+ Calligraphy pen

+ Nib (such as a Nikko G)

+ Ink color of choice (gouache or Dr. Ph. Martin's Iridescent Copper ink)

+ A2 envelope for the card

How To

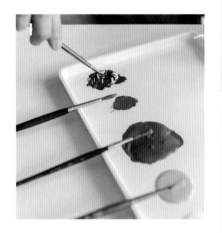

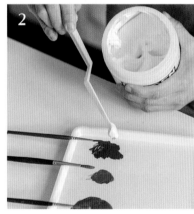

3

4

5

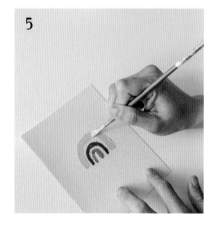

8

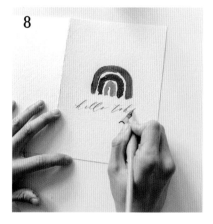

9

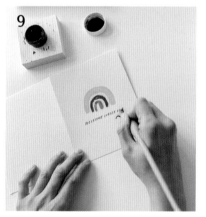

INSTRUCTIONS

1 Start with building the color palette you want to use for the project. Squeeze a bit of gouache from the tube onto your palette and mix it in the shades you are looking to use for your rainbows. You will need to make about ½ teaspoon of paint per color, for a total of three to four complementing shades. Try creating the following 4 colors:

Pale Blush: Mix white and a bit of red.

Mustard: Mix yellow and brown.

Terra-Cotta: Mix red, orange and a bit of brown.

Rust: Mix red and brown.

2 Use a spatula to add about ½ teaspoon of the gel medium to "multiply" and add dimension to each of the paint colors. This will make the paint dry with peaks, instead of flat on the paper. You will need to mix the gel medium and paint together for about 1 minute, until the gel is completely combined with the paint.

3 Once the paints are ready, use a brush to paint a small half circle on the watercolor paper. Don't add water to it—the paints need to be as opaque as possible.

4 Paint a second line that surrounds the first half circle in a different but complementing color.

5 Paint a third line that surrounds the second half circle in a different but complementing color.

6 You can choose to create more lines or make smaller rainbows across your card—it's time to get creative!

7 Let the paint dry. Because of the gel medium, it may take about 30 minutes to dry. While you are waiting, wash your brushes in the container of water, as the gel medium will harden and may ruin the brushes if the paint dries on it. Finally, using a pencil, outline the words of your greeting.

8 Fit the calligraphy pen with the nib. For the calligraphy writing, you can use copper ink, or you can mix some paint and add some water to it, then use a brush to brush the "ink" onto your nib. Do not use the paint that has the gel medium, because it will not flow properly as ink.

9 After the card has dried completely, pair the card with the A2 envelope.

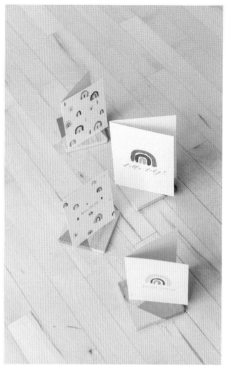

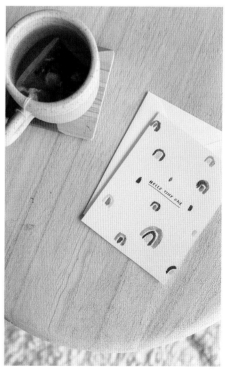

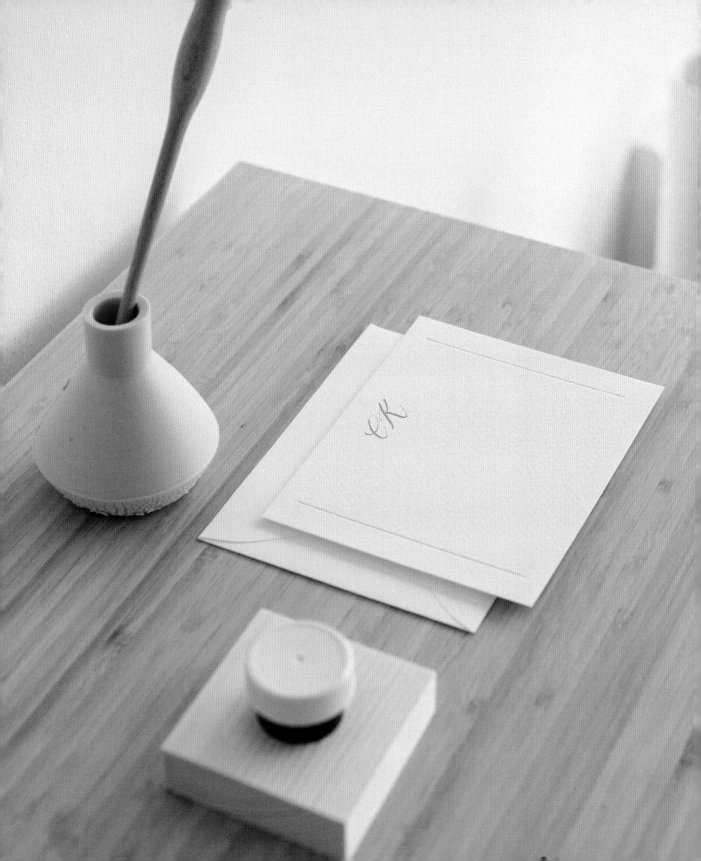

ELEGANT EMBOSSED MONOGRAM STATIONERY SET

Who here loves receiving beautiful stationery? I've got my hand raised as high as possible. I especially love those timeless designs that can be used season after season, occasion after occasion. For example, after our wedding day, my husband and I wanted to send some thank-you notes to people, so we created personalized stationery pieces that were simple yet elegant and timeless. We still keep a stack of these cards for whenever we have to attend a wedding, go to a birthday party or send some congratulations.

In this tutorial, you are going to learn how to use the scoring knife to create debossed lines on the cards, which creates a beautiful, minimalist look. Then you'll learn how to create monogram initials that really elevate the look of this stationery set. Once you finish this gorgeous set of paper, you will need to pair it with some complementing envelopes. Not only are these amazing for your everyday use but you can also use them as a gift!

+ Scoring device or scoring knife and ruler
+ Washi tape
+ Cutting mat (not required if using the scoring device)
+ 10 (4¼ x 5½-inch [10.8 x 14-cm]) cards cut from cold press watercolor paper
+ Pencil

+ Calligraphy pen
+ Brause Steno Blue Pumpkin nib
+ Dr. Ph. Martin's Iridescent Copper Plate Gold or Copper ink or ink of choice
+ Eraser
+ Envelopes for the cards

How to

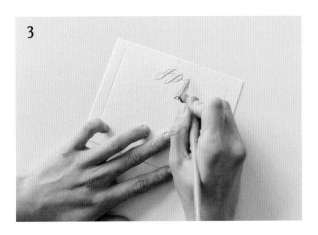

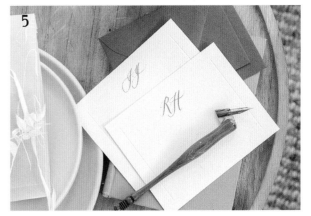

INSTRUCTIONS

1 On your scoring device, create a marker with the washi tape for ½ inch (1.3 cm) from the top and the bottom of the card, horizontally oriented. This way, when you score your card, you will know exactly where to stop. Alternatively, if you are using a scoring knife, ruler and cutting mat, create a marker using a pencil on the card in landscape orientation. You will be making a score line that is 3¼ inches (8.25 cm) long, with top and bottom margins of ½ inch (1.3 cm). The resulting product will have two vertical embossed lines on the left and right of the landscape-oriented card.

2 Score two lines on each card.

3 Now it's time to write the monogram letters. You can refer to the templates on my website for inspiration, as I have included some monogram samples. Practice a couple of times with the letters you wish to use. Then measure a ½ inch (1.3 cm) from the top as a margin. Use a pencil to outline the initials in the monogram style that you have chosen. Fit the calligraphy pen with the nib. Finally, trace over the pencil outline with the calligraphy pen, nib and ink.

 Repeat the process to finalize the other cards.

4 Using an eraser, carefully erase the remaining pencil marks around the letters.

5 Pair the cards with complementing envelopes.

MONOGRAM SAMPLES

Mr. and Mrs. Scott Woods
1201 North Garland Boulevard
Lake Forest, Illinois 60601

Mr. and Mrs. Scott Woods
1201 North Garland Boulevard
Lake Forest, Illinois 60601

Ms. Jamie Reid Anderson
474 Franklin Avenue, Apartment 1D
Brooklyn, New York 11238

ALL YOU NEED TO KNOW ABOUT ADDRESSING ENVELOPES IN CALLIGRAPHY

There's something extra classy about envelopes written in calligraphy. Now that you've created some gorgeous cards with calligraphy and some crafting skills, the next step is to make your envelopes stand out with calligraphy. Addressing an envelope in calligraphy is a beautiful way to elevate the experience of receiving your card, whether it's a simple thank-you note or a wedding invitation. Over the years, I've written thousands of envelopes that have been delivered all over the world. So I definitely have some tips and tricks to help you address envelopes properly.

One thing I must note about addressing envelopes is the importance of understanding your postage system's addressing rules. Every country has different rules and etiquette, so make sure that you are aware of what the requirements are and to reflect them through the addresses when you're setting them up.

Tools you'll need

+ List of addresses, printed out on a sheet of paper
+ Calligraphy pen, nib and ink

+ Envelopes
+ We R Memory Keepers® laser level or any laser level with a clipboard

Mr. and Mrs. Scott Woods
1201 North Garland Boulevard
Lake Forest, Illinois 60601

Ms. Jamie Reid-Anderson
774 Franklin Avenue, Apartment 1D
Brooklyn, New York 11238

Dr. and Mrs. Jon Stark
5590 Castle Black Point
North of the Wall, Reykholt
E9 RV90
Iceland

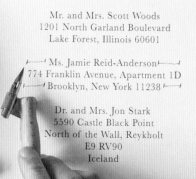

Mr. and Mrs. Scott Woods
1201 North Garland Boulevard
Lake Forest, Illinois 60601

Ms. Jamie Reid-Anderson
774 Franklin Avenue, Apartment 1D
Brooklyn, New York 11238

Dr. and Mrs. Jon Stark
5590 Castle Black Point
North of the Wall, Reykholt
E9 RV90
Iceland

SETUP

It's important to have a reference point while addressing envelopes in calligraphy, even if you know exactly what you are about to write. Printing the addresses out on a piece of paper, line by line, aligned in the format you require them to be, will help you visualize the end product. This way, you can focus on the style and writing of the letters rather than on the text itself. Writing addresses left aligned is the easiest. Center aligned is a bit harder, and right aligned is the hardest of all. Make sure that you print the names, addresses and additional lines in a clear, legible font.

For example, print your document similar to the following examples.

Left aligned:

Mr. and Mrs. Everett Teaford
2589 Marine Drive
Long Island City, New York 12401

Center aligned:

Mr. and Mrs. Everett Teaford
2589 Marine Drive
Long Island City, New York 12401

Right aligned:

Mr. and Mrs. Everett Teaford
2589 Marine Drive
Long Island City, New York 12401

Once I have printed out the addresses, I usually also use a piece of paper or bookmark to hide the following addresses so that as I refer to the addresses, my eyes can focus on the one I'm working on. I've wasted plenty of envelopes because I wrote the name of the first entry but wrote the address of the second entry.

LASER GUIDE

This tool helps you write on a straight line using a movable laser guide. This solved the century-long problem of drawing lines on envelopes, especially on darker envelopes. This tool has a clipboard and an adjustable laser guide that you can move as you go from line to line. To set it up, I typically measure the middle of the envelope and put markers, such as washi tape, where my envelopes will need to be. I also measure where the first line should sit, so that it will be consistent from one envelope to the next. If you don't have a laser guide, you can use a ruler to draw guide lines in pencil.

WORKSPACE

Make sure that you are in a spacious, well-lit place and that you are seated. Having tons of space is important because you need an area dedicated to drying your envelopes after you have written on them, and it is safest to dry them while they are lying flat. I usually have a section to the left of my writing space that can hold at least nine envelopes, three in a row and column. The space to the right has my ink, pen and new envelopes, and the middle section has the laser guide, the reference document and the envelope I'm currently writing on. Being seated is also important for addressing envelopes because consistency is key. You want to ensure that you are in the right angle every single time—if you are standing, the angle may shift often.

WRITING SUPPLIES

To write multiple addresses, I have to ensure that I have multiples of the nibs and envelopes I need to write with. For envelopes, while you are starting out, you may need extras just in case you make a mistake.

Make sure you have ample ink for the project, especially if you are mixing gouache paint for your project. Also, make sure that you test the ink, envelope and pen combination before you start with the large project. Here are some things to consider:

1 **Texture of the envelope:** Some nibs work best with smoother paper, and some are more flexible with textured paper, such as handmade paper.

2 **Color of the envelope:** Some ink colors look different when written on a colored envelope, so you may need to adjust the shade, especially if you are working with gouache ink. The color of gouache ink also tends to dry a different color than how it appears when it is wet, so make sure you test before you write—and wait until it dries completely before moving on.

3 **Finish of the envelope:** Some envelopes come with a coating that would be difficult to write on with some inks. You may need to consider sumi ink or metallic inks to work on them rather than gouache.

How to

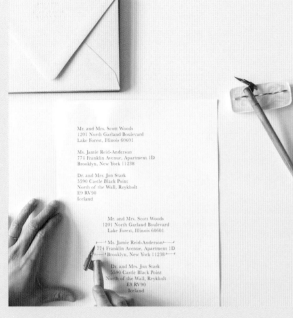

Mr. and Mrs. Scott Woods
1201 North Garland Boulevard
Lake Forest, Illinois 60601

Ms. Jamie Reid-Anderson
771 Franklin Avenue, Apartment 1D
Brooklyn, New York 11238

Dr. and Mrs. Jon Stark
5590 Castle Black Point
North of the Wall, Reykholt
E9 RV90
Iceland

Mr. and Mrs. Scott Woods
1201 North Garland Boulevard
Lake Forest, Illinois 60601

Ms. Jamie Reid-Anderson
774 Franklin Avenue, Apartment 1D
Brooklyn, New York 11238

Dr. and Mrs. Jon Stark
5590 Castle Black Point
North of the Wall, Reykholt
E9 RV90
Iceland

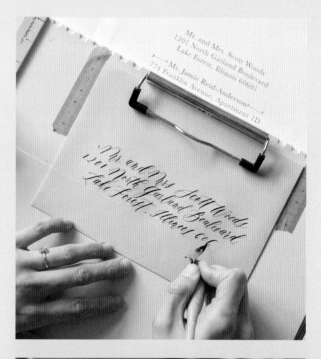

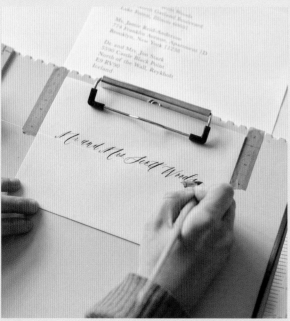

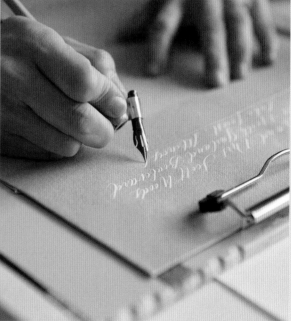

HOW TO WRITE CALLIGRAPHY ON ENVELOPES

Now that you've got your addresses ready, your workspace set up and your supplies ready to go, it's finally time to write!

1 Start by placing an envelope on your clipboard, making sure that it's centered and not crooked (unless you're planning to do slanted addressing). The markers should help with this step.

2 Dip your pen into the ink and start with the first address on your list. Take a close look at how it is aligned on your reference document, then write the name on the first line. Depending on the length of the name, you may need to rewrite the envelope to ensure that the addressing is laid out correctly on the card. For center-aligned envelopes, most of the time singular names start at around 2 inches (5 cm) from the left. Couples' names start at around 1 or 1½ inches (2.5 or 3.8 cm) from the left, depending on how long they are. Longer names take the entire span of the envelope, so you can start at ⅓ inch (0.3 cm) from the left.

3 Refer to the second line and outline the address accordingly. For example, if the second line started three letters before the first line, then do the same and adjust your starting point on the envelope. Make sure you also leave ample room between the lines, as you don't want the descenders of the first line and the ascenders of the second line to overlap. At times you may need to write words with a bit more space between the letters to avoid overlap. The spacing between lines will depend on your preference, but it is important to measure your regular letter height, as that way it can be consistent throughout your addressing. For example, if your writing is typically ¾ inch (1.9 cm) tall, you may need to allow ½ to 1 inch (1.3 to 2.5 cm) for the next line depending on how loose or tight you are hoping the overall layout to be.

4 Repeat the preceding process on the subsequent lines. Once you are done, unclip the envelope and set it aside to dry. Keep repeating the process until you finish writing all of your addresses.

UNIQUE LAYOUTS

While it may seem really exciting to do some unique vertical layouts or wave layouts, please note that the more complicated the layout is, the harder it will be for the mail carrier to read it. So, unless you are hand-delivering these envelopes, make sure that the layout is in a readable format. To help ensure delivery, consider paying extra for hand-canceling envelopes (envelopes are typically read by machines), so that they can be manually sorted and delivered to the right place.

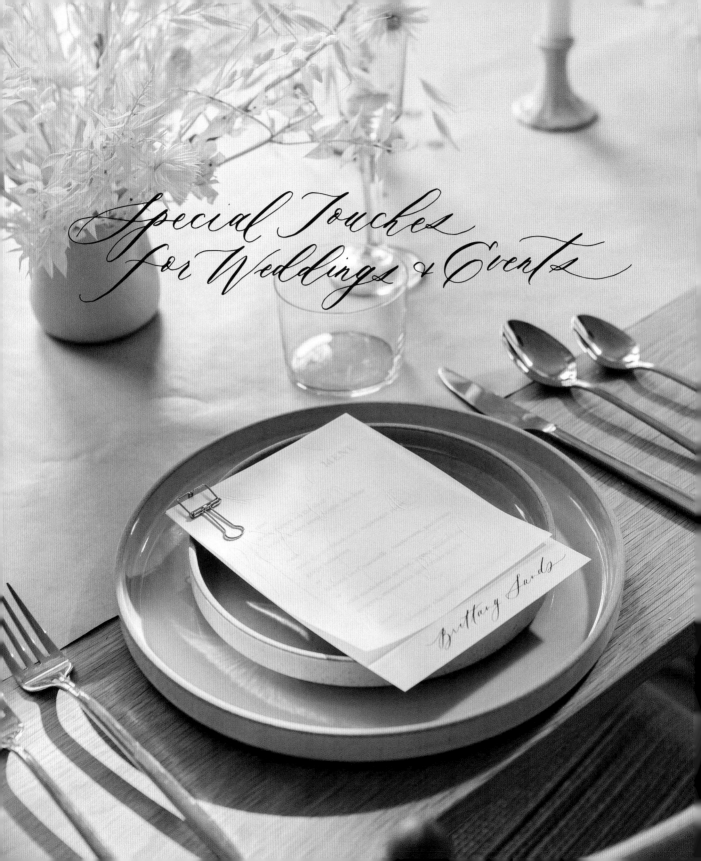

Special Touches
for Weddings & Events

A wedding is such a special event, not just for the couple but also for their friends and family. Not only does a wedding celebrate the love of the couple, but also it's a huge thank-you to the people who have been there for the couple. I love creating all sorts of details that tell a bit of the couple's story—whether it's an illustration of where they first met or a pawprint of their dog, a little something always goes a long way. Often, not long after my couples get married, they become parents or have more special events that I also get to be a part of. Creating details for weddings and other events has always been special for me. It's where my business started. And over the years, I've been able to develop a style for wedding stationery that is uniquely mine—romantic and timeless with a touch of modernity. My clients know that I pay attention to the details and ensure the cohesive, intentional look of the stationery, so that the style is woven throughout the various details.

This section is all about creating some of these event details using calligraphy, such as menus, place cards and seating charts—all of those personal touches that are going to make everyone swoon and make things memorable, cohesive and extra special. You're going to learn how to use some simple elements to elevate your events, some of the best practices for laying out larger pieces of work—such as seating charts—and how to use calligraphy on different surfaces, like fabric, to create a linen menu that you can hang on your mantel. There are two different looks that you'll notice in this section of the book: One has a cleaner, modern, Scandinavian-inspired look that incorporates minimal illustrations and vellum, while the other has a more organic, old-world feel with touches of warm color tones.

PERSONALIZED BRIDESMAID CARD
AND GIFT BOX

Ah, what a blessing it is to be surrounded by your girl squad on your most important day! These girls, they have your back. Gift-giving has always been a passion of mine. I love packing these gift boxes for my special friends and clients. I'm really excited about this project, because I get to share with you my secret for curating a gift box: rebranding! You know those pretty gift boxes that you see on Pinterest? While they look good, you and I know that the contents aren't always what your friend needs or wants. What's so special about the bridesmaid box is that you want to curate something that is perfect for the recipient, because that's just part of the way you want to say thank you. So, in this project, I am going to share another card idea, which is all about the invitation to be a bridesmaid, then you're going to learn how to create labels for various items. This way, you will create a cohesive look to your gift box while finding the exact things your recipients need.

A few things to take note of while you fill your bridesmaid box with various goodies:

- **Set a budget:** Just so you don't break the bank, set a budget for each box so that you know how much you're going to spend.

- **Find a good gift box:** I recommend getting a decent-sized box, such as an 8 x 8 x 4-inch (20.3 x 20.3 x 10.1-cm) box—that way you can plan the size of the gifts around the box. If the box is too small, it will be harder for you to find items that can fit in it; and if the box is too big, it will be harder to fill the box with items.

- **Find some essentials:** Not every single gift box needs to be unique. Some items can be the same, such as candies, chocolate bars or candles. If you are purchasing these items from a small shop, like a shop on Etsy, you can possibly get a bulk discount if you have 5 to 10 items.

Supplies FOR THE CARD

+ Pencil (such as a 9H)
+ 8½ x 5½-inch (21.6 x 14-cm) Bristol paper or light-colored blush paper (Vellum White Matte cardstock from Cards & Pockets or similar), scored in half

+ Calligraphy pen
+ Nib
+ Dr. Ph. Martin's Iridescent Copper Plate Gold ink

Supplies FOR LABELS, GIFTS AND BOX

+ Gifts to put inside the gift box (such as candles; champagne; a wineglass or mug [see instructions]; candy or chocolate; hand cream; hair clips; a notebook; a cardholder)
+ Scissors
+ Cardstock (Vellum White Matte cardstock from Cards & Pockets or similar)
+ Calligraphy pen
+ Nib
+ Ink of choice

+ Light pencil (such as a 9H; optional)
+ Eraser (optional)
+ Double-sided tape
+ Disinfecting wipe
+ White oil-based paint pen
+ Packing supplies (such as crinkle paper or wood excelsior)
+ 8 x 8-inch (20.3 x 20.3-cm) white cardboard or wooden box

SUGGESTED QUOTES

+ For your sweet tooth
+ A toast to our friendship

+ For all your hard work
+ Keep me zen, will ya?

How to

1

3a

3b

4

5

6
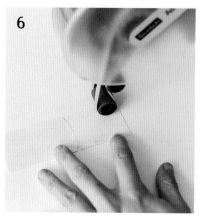

8

9

10
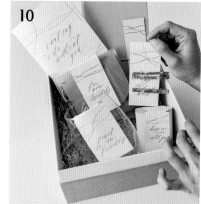

BRIDESMAID CARD

1 Use a pencil to draft the quote you want to write on the scored card-stock. Fit the calligraphy pen with the nib. Then use the calligraphy pen to write over the pencil outline in the gold ink.

2 Add some streaks that resemble waves or abstract lines using the calligraphy pen and ink.

LABELS, GIFTS AND BOX

3 To make the labels, remove any stickers or excess packaging from the gifts that are not in the color scheme of the gift box and card. Using scissors, cut a piece of cardstock that is about 1½ inches (3.8 cm) wide—the length of the cardstock will depend on the item you are putting it on. Do this for each item you are going to label.

4 Fit the calligraphy pen with the nib. Add a quote to each label using the calligraphy pen and ink. If needed, use a pencil first to outline the letters, then erase these lines after everything is dry.

5 Decorate these labels with wavy abstract lines at the top of the cardstock labels.

6 Add a label to each item with the double-sided tape.

7 To prepare the wineglass, wipe down the glass with a disinfecting wipe.

8 Write the recipient's name in faux calligraphy using the oil-based paint pen. You will need to write the name in monoline first, then thicken the downstrokes accordingly, taking into consideration the top and bottom transition points. Note that this paint will not be permanent and is not dishwasher-friendly.

9 To prepare the box, place the crinkle paper or wood excelsior in the box. Use double-sided tape to attach the labels on the various products.

10 Arrange the gifts and bridesmaid card in the box so that your guests can receive them perfectly.

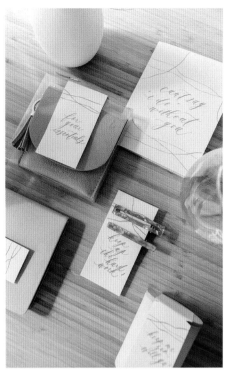

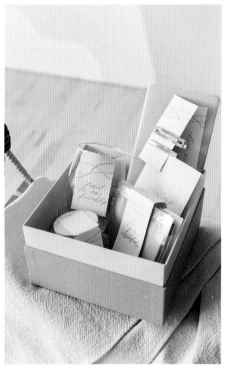

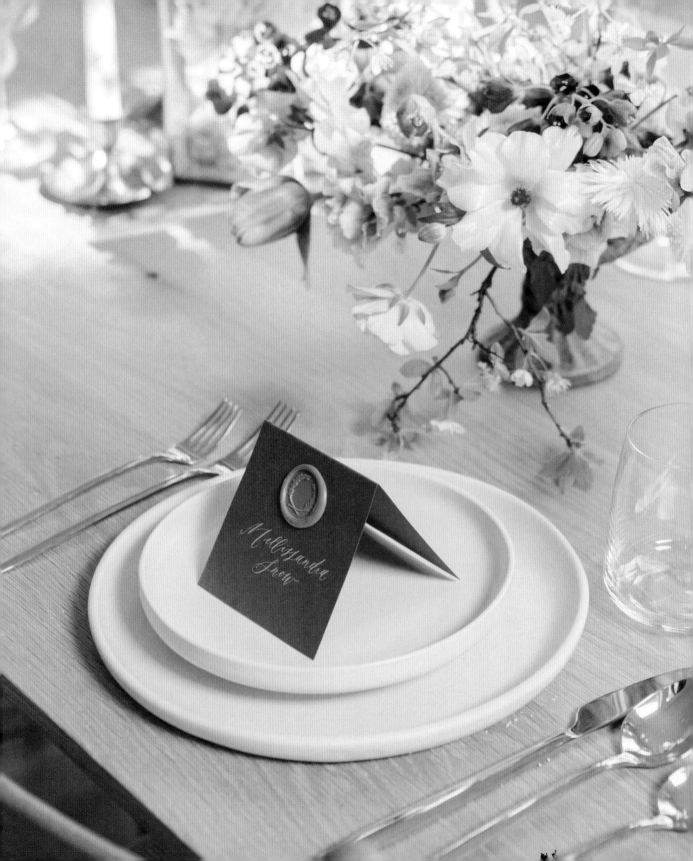

MONOCHROMATIC WAX SEAL PLACE CARDS

Place cards are a great way to dress up your dinner table, whether it's for Thanksgiving dinner or just a get-together with friends. When you use place cards, each person gets a little name tag, and it also doubles as a keepsake. This crafting project will make you a wax seal addict. There's something beautiful about the old-world tradition of wax sealing, and in this tutorial you are going to learn the nitty-gritty tips and tricks. If you haven't yet tried making wax seals, well, you're in for a treat! They are so much fun and not too difficult once you get the hang of the process. Wax seals were originally used to seal important documents and to ensure that the contents of the envelope were not read by someone who wasn't supposed to see them. Nowadays, they're more for decoration than security and they're actually unbreakable, so that they will survive during transit in the mail. Decorative or functional, they will definitely make your place cards timeless and elegant—perfect for a nice dinner with friends and family.

If you haven't yet noticed, I love monochromatic, cohesive palettes. And in order to re-create that look in a wax seal, I need to get the right color cardstock and sealing wax to match. I've outlined where to find these materials in the resources guide at the back of this book (page 170).

+ Ruler

+ Scissors

+ Beige, rust and ivory cardstock (such as Harvest from Cards & Pockets, Ivory from Cards & Pockets and Sepia from Gmund)

+ Scoring device

+ Wax sticks for glue gun in colors of choice (such as Artisaire Terra, Bright White and Classic Grey)

+ Regular-sized glue gun (preferably with a dual heating setting)

+ Parchment paper

+ Wax seal of choice (such as Written Word Botanical Wax Seal)

+ Cool gel pack

+ Calligraphy pen

+ Nib

+ Ink of choice (such as Dr. Ph. Martin's Pen-White or Dr. Ph. Martin's Iridescent Nickel)

How to

1

2

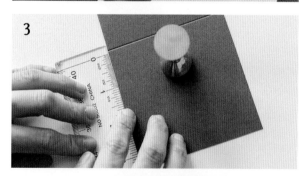

3

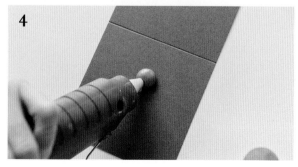

4

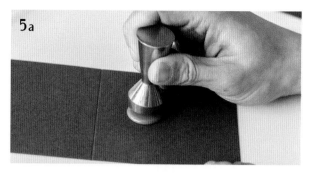

5a

5b

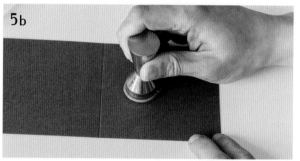

6

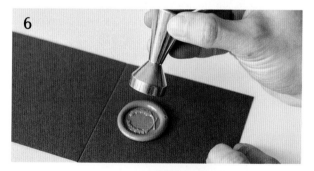

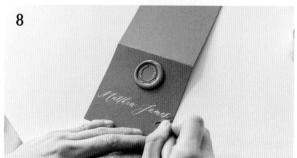

8

INSTRUCTIONS

1. Count how many people you have in your party, and multiply that number by 1.5 (so that you will have extra place cards if needed). Using a ruler and the scissors, measure and cut out as many 3½ x 7-inch (8.9 x 17.8-cm) cards as you need from the cardstock. Score the cards in half using a scoring device so that they fold into 3½ x 3½-inch (8.9 x 8.9-cm) tented cards.

2. Insert a wax stick into the glue gun and turn it on to the low heat setting. Put the parchment paper underneath the glue gun to catch any drippings. Let the glue gun heat up the wax for approximately 5 minutes. (Tip: Practice making wax seals on some parchment paper before creating the place cards.)

3. Mark the spot where you would like to have the wax seal on the place cards. Usually, the ideal spot is about a ½ inch (1.3 cm) below the center of the card.

4. Squeeze out about a ¾-inch (1.9-cm) circle of wax from the glue gun. It may require two or three squeezes, depending on your gun and how hot the wax is.

5. Make sure your wax seal is facing the right direction, then slowly press it into the wax.

6. Slowly lift up the wax seal after 10 to 30 seconds. The time needed really varies with the wax. Some brands get very hot, so you may need to let the wax cool down before lifting the seal.

7. Put the seal on the cool gel pack to cool down. Before you use it again, double-check if any condensation has appeared on the seal. If so, wipe off the water before using the seal again.

8. Once the wax seals are all cool, fit the calligraphy pen with the nib. You can write the person's name in calligraphy using your ink of choice under the wax seal. You should have some extra place cards to work with.

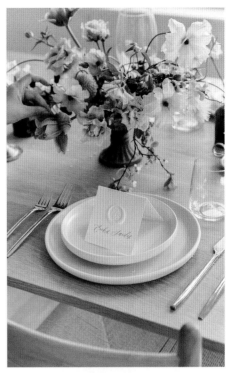

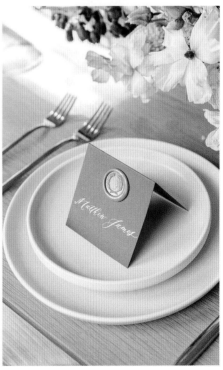

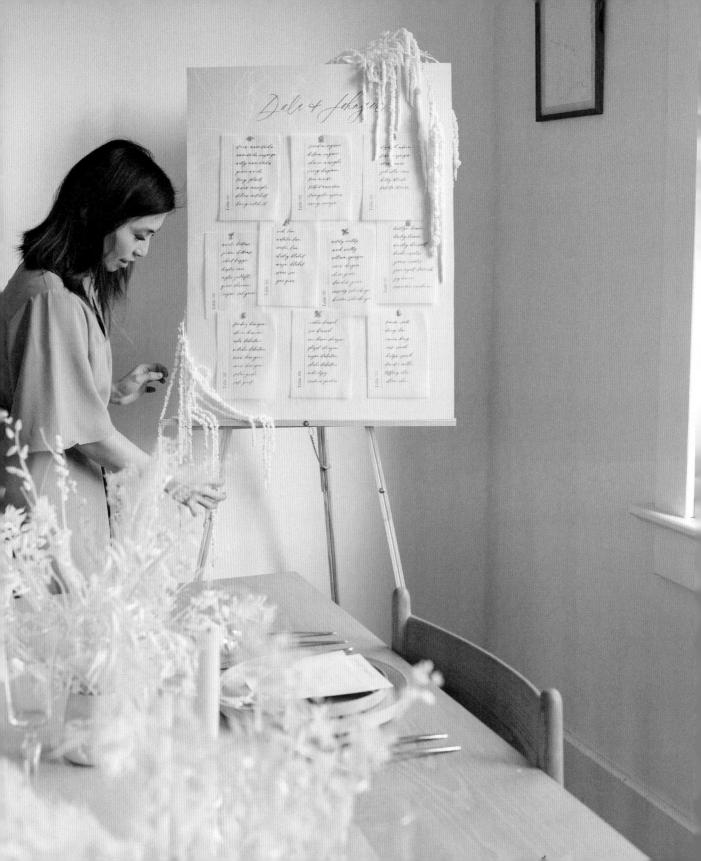

MODERN ILLUSTRATED SEATING CHART

The seating chart is what the guests check to see where they're seated at a wedding reception. Often, the seating chart is one of the few personalized pieces that people get to see once they enter the reception. So its look should be cohesive with your entire wedding style.

Regardless of the layout style, writing seating charts can be quite daunting. There are so many names, and you feel the pressure to get everything to fit correctly! Plus, for most weddings, there's always some last-minute changes, so the time is a bit tighter. In this tutorial, I'm going to share some of my best practices for creating seating charts so that you can avoid making mistakes and so that you can anticipate the changes and the amount of work they would require while still creating something beautiful that your clients or guests are going to love.

One of the most important parts of creating a seating chart is the planning process. Usually, my time is spent measuring the board, marking things with a pencil and drawing lines, so that I can ascertain the text that will be put on the board. Because of how tedious the planning can be, I do a lot of my planning on my computer using Adobe Illustrator, but you can certainly make this happen using other similar programs. Then I re-create the work on the actual board, so that I can reduce the margin of error. This particular style of seating chart will also be on a per-table basis, which will list names in groups of 6 to 10. This way, you won't need to redo the entire seating chart when there are a lot of changes—just update one of the tables instead.

+ 20 x 30-inch (50.8 x 76.2-cm) Legion Stonehenge paper or Bristol paper

+ White acrylic paint pen

+ 20 x 30-inch (50.8 x 76.2-cm) foam board

+ Double-sided tape or glue

+ Ruler

+ Pencil (such as a 9H)

+ Tombow Fudenosuke Soft Tip Brush Pen in black

+ Eraser

+ Pushpins with butterfly backs

+ Calligraphy pen, nib and sumi ink

How To

3

4

5

6

7

8

9

INSTRUCTIONS

1 Create a reference file using Adobe Illustrator or InDesign to ensure that you know what the final layout will look like. This will ensure that all the names will fit. If you don't have these programs, you can still do this in Microsoft Word or Pages, but you may need to scale it down. Alternatively, you can also do some math and measure manually by dividing the space by the number of names you will need to fit per column. Don't forget to consider spacing and margins. Print out this document as a layout sheet, and include the measurements as well.

2 Print out the seating chart, table by table, into 5 x 7-inch (12.7 x 17.8-cm) sheets. You will be putting the vellum sheets on top. The vellum sheets are translucent, so you can see the names underneath.

3 On the sheet of Legion Stonehenge paper, draw out loose florals using the white acrylic paint pen. This will serve as the background of your seating chart. You will need to attach this seating chart to the foam board as a backing using double-sided tape.

4 With a ruler, measure the title of your seating chart, such as the names of the couple. Make sure you include margins all around the seating chart. Use a pencil to draw those margins if you need it, being sure to erase the pencil marks later.

5 Use the Tombow Fudenosuke pen to write the names of the couple on the top of the seating chart.

6 Align a 5 x 7-inch (12.7 x 17.8-cm) vellum sheet on top of each printed table sheet.

7 Fit the calligraphy pen with the Nikko G nib. Using the printed table sheet as a reference, write each name using the calligraphy pen, nib and sumi ink.

8 Once you have written all the tables, it's time to lay them out on the seating chart. Use the printed reference file to lay out your cards, including the space between each card.

9 Attach the vellum sheets to the seating chart board using the pushpins, and secure them in the back to ensure that they do not move.

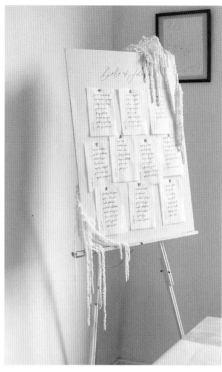

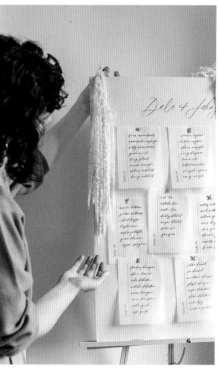

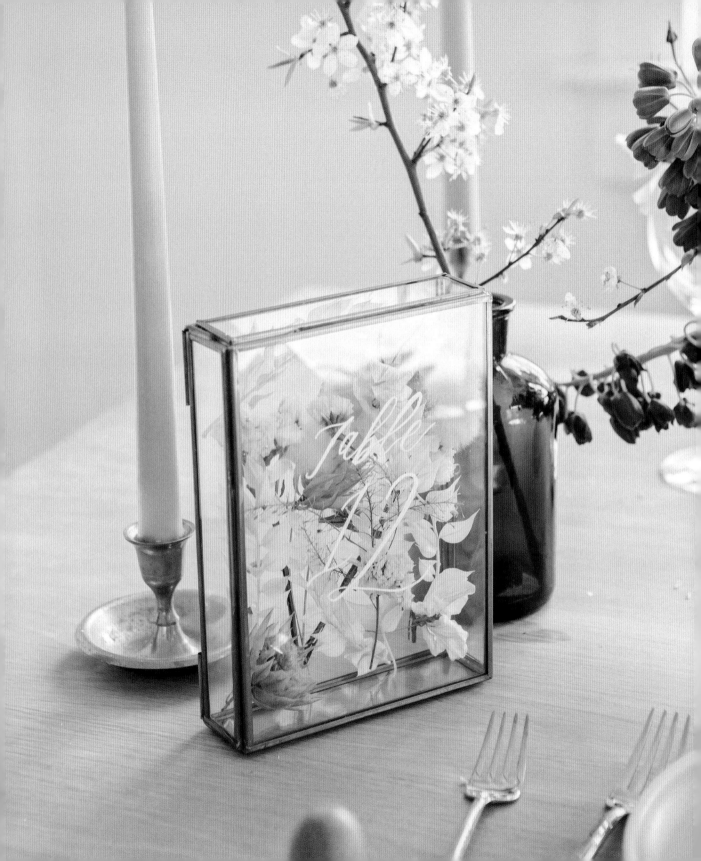

STYLISH FLORAL BOX TABLE NUMBER

Now that the guests know where they're seated, it's time to write the table numbers for the tables. The key is to make the numbers large enough to be visible from afar, so that when the guests are walking around, they will be able to quickly see the table numbers. One of my favorite ways to create table numbers is to use a glass box—it makes the lettering stand out, and there are many ways you can dress up this design by adding some foliage or even fresh flowers inside. The beauty of this shadow box display is that you can use it again for another wedding or event; you'll just need to fill it up with different florals or foliage the next time around.

In this tutorial, you're going to play florist and curate the foliage: You'll cut and arrange the florals to create a pretty backdrop for the glass box. Then you're going to learn some of the techniques for writing on glass using a marker and your newfound faux calligraphy skills. However, remember that whenever you write on glass, the paint markers are not permanent. If you prefer to create a permanent table number, you will need to engrave the glass and fill it in with white instead.

Supplies

+ Piece of paper cut to the size of the gold glass display box

+ Pencil (such as a 9H)

+ Rubbing alcohol wipes or disinfecting wipes

+ 5 x 7-inch (12.7 x 17.8-cm) or larger gold glass display box that can open and close

+ Oil-based paint pen (such as white or gold; see Tips and Tricks)

+ Fillers for the box (such as branches, fresh flowers or dried flowers)

+ Scissors

How To

1

2

4

5a

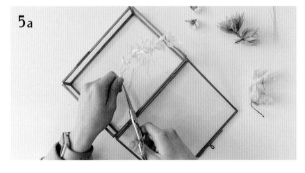

5b

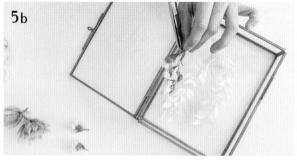

5c

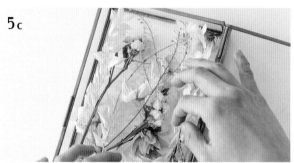

6a

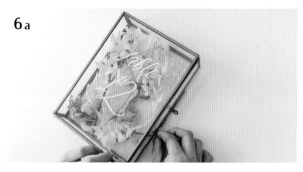

6b

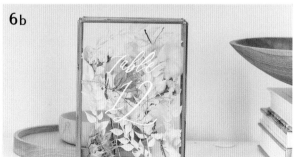

Tips and Tricks

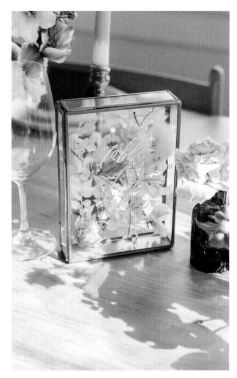

+ While this is an oil-based paint pen, it's not permanent. You can remove it using rubbing alcohol with a bit of effort once it's dry. Work done with an oil-based paint pen should not be washed.

INSTRUCTIONS

1 On the piece of paper cut to the size of the display box, use the pencil to outline the design for the table numbers. You can write the numbers in a variety of ways; for example, Table 1, 1 or One.

2 Use rubbing alcohol wipes to clean the lid of your box where you will be writing. Wipe the box dry.

3 Put the sheet of paper inside the display box. You will be writing on the lid, so you will use the sheet of paper as a guide for you to trace onto the lid.

4 If this is the first time you are using the paint pen, you will need to test it out on a scrap piece of paper first, and press down a couple of times to get the paint going. Start tracing and writing the table number. Create the monoline (regular pressure, medium line) first, and then double up on the downstrokes to create a thicker stroke. If you make a mistake, use the edge of the rubbing alcohol wipes to wipe off the design.

5 Arrange the fillers inside the box. Use scissors to snip the fillers' ends if necessary. You want the box to be full enough that things won't fall down when you stand it up.

6 Close the box's lid and display the table number on your table or on top of a cube and decorate around it with dried florals.

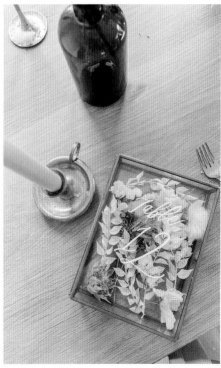

In Everything Give Thanks

starter

roasted beet & celery root salad
with walnuts, gala apples
and lemon confit

mains

wild mushroom lentil loaf
roasted root vegetable bisque
with walnut gremolata
herb and red wine braised turkey
with peppercorn glaze
maple sweet potato mash with
rosemary gravy

dessert

peppermint tarte la creme
de chocolat with roasted cashew oat
crust and whipped coconut cream

HANDWRITTEN NATURAL LINEN FABRIC MENU

Nothing's more exciting than anticipating a delicious home-cooked dinner. Are you preparing your home for a special dinner, a dinner where you're going all in? Are you preparing that turkey and making all sorts of desserts and decorating the mantel and table as well? Write out your menu on gorgeous linen fabric and hang it by the door of your dining room or in front of your dinner table. This is a really fun project because it will exercise your calligraphy skills on a larger sheet, and you'll get to use a brush pen too.

Writing on fabric with a brush works so much better than with a calligraphy pen—a brush can easily go over the textured surface of fabric, especially linen, better than a calligraphy pen. Calligraphy pens just can't write on rough surfaces, and the ink won't flow smoothly either. When you are writing with a brush, you need to keep the same concept of upstrokes being light and downstrokes being heavier.

Whenever I work on a large project like this, I cannot emphasize how important it is to prepare and measure beforehand to reduce errors. Make sure you print out your menu, so that you have a physical reference of the text in the layout you need. With a reference document, you can easily determine how many words will fit on a line, versus simply writing and not knowing if it will fit.

+ Menu printed on a piece of paper, center aligned

+ Ruler

+ 2 yards (1.8 m) linen fabric

+ Scissors

+ Kraft paper or any gift wrapping paper

+ Pencil (such as a 9H)

+ Tombow Fudenosuke Soft Tip Brush Pen in black

+ Clear fishing line

How To

1

In Everything Give Thanks

starter

roasted beet & celery root salad
with walnuts, gala apples
and lemon confit

mains

wild mushroom lentil loaf
roasted root vegetable bisque
with walnut gremolata
herb and red wine braised turkey
with peppercorn glaze
maple sweet potato mash with
rosemary gravy

dessert

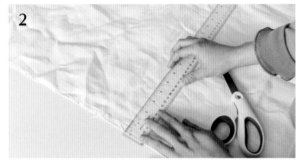

2

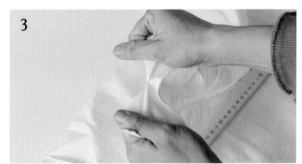

3

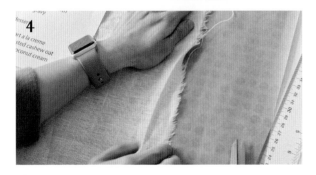

4

5

6

7

Tips and Tricks

+ Note: If you make a mistake, don't worry about crossing it out, just keep writing. Most of the time, people won't notice that you've misspelled something unless you cross it out! Instead, you can add some illustration as that will typically draw attention away from the mistake.

+ This method is for one-time use of the menu, and the menu is not washable. If you want to iron your linen menu to make it less wrinkly, do not use steam. Iron the reverse side with a cotton cloth placed on top of your menu.

INSTRUCTIONS

1 Create the menu in Adobe Illustrator or Microsoft Word, measuring everything with margins. Take note of the line breaks so that you won't have awkward lines on the menu. Make sure the menu is centered.

2 With the ruler, measure the width of the linen fabric—usually between 24 and 36 inches (61 and 91.4 cm)—and snip a bit at the top with scissors.

3 Hold on to the two opposite ends and tear the fabric by hand. This will create a beautiful frayed look that is organic and yet homey.

4 Prepare your workspace by laying down some kraft paper on your table. This will help ensure that the ink will not go through your fabric and onto your table.

5 Place the linen fabric on top of the kraft paper. On the fabric, measure everything out using a ruler and pencil. Make sure there is at least a 10-inch (25.4-cm) margin from the top, and about a 6-inch (15.2-cm) margin on both sides of your menu. Creating the markers will help you write well and execute your project with confidence.

6 Use the Tombow Fudenosuke Soft Tip Brush Pen to write out the menu. Keep the upstrokes light and the downstrokes thick, bearing in mind the bottom and top transition points. Refer to the faux lettering section (page 24) for additional instructions. If you need some practice, write the letters on a piece of scrap fabric first before you write on the linen fabric.

7 Finally, add a bit of string on the top corners and use that to hang it onto the walls.

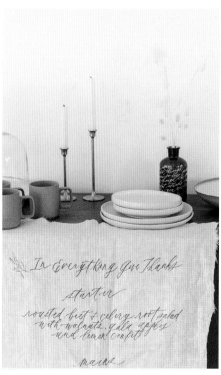

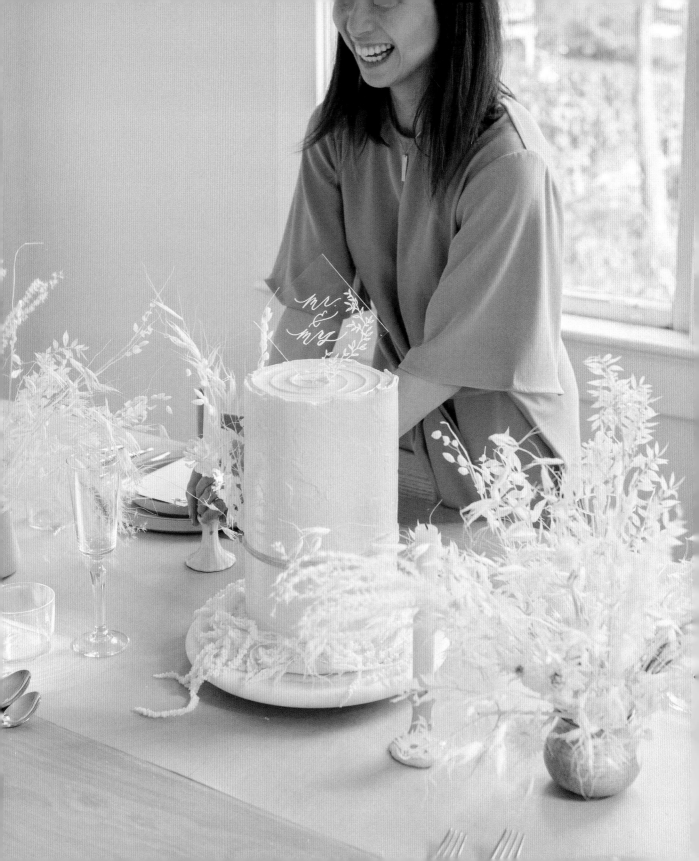

MINIMAL DIAMOND ACRYLIC
CAKE TOPPER

Do you love creating sweet somethings for the special people in your life? I've been so blessed to live near my family, and we try to celebrate each birthday together with a delicious meal and a cake. A beautiful way to dress up a special-occasion cake is with a personalized cake topper. This simple yet stunning transparent cake topper requires a pen, a square acrylic piece and a gold leaf pen. To make it less daunting, we will create a template to refer to, so that you will be tracing it on the acrylic. Writing on acrylic is similar to writing on glass, which you have already done for the Stylish Floral Box Table Number (page 75). The acrylic surface is more accepting of markers than calligraphy nibs, so you will be using faux calligraphy techniques (page 24) in order to make this happen. This gold geometric cake topper is great for baby showers, bridal showers, birthday parties and the like!

+ 4 x 4-inch (10.1 x 10.1-cm) piece of paper

+ Ruler

+ Pencil (such as a 9H)

+ 4 x 4-inch (10.1 x 10.1-cm) acrylic piece

+ Rubbing alcohol wipes or disinfecting wipes

+ Paper towels

+ White oil-based paint pen or Sakura Pentouch® paint marker in gold

How To

1

2

3

4

5

INSTRUCTIONS

1 Turn the piece of paper on its side so that you have a 4 x 4–inch (10.1 x 10.1–cm) diamond. At the bottom, use a ruler to measure a 1-inch (2.5-cm) triangle and draw a line with the pencil. This will serve as the margin for your design, as this portion will be placed in the cake.

2 Use the pencil to write what you want on the cake topper. Make sure you account for lots of space, as the gold leaf pen writes bigger and wider than the pencil. Draw some florals or foliage around the words. This will serve as the template for your cake topper.

3 Take the protective film off the acrylic piece and wipe it down with rubbing alcohol wipes. This will help prepare the surface for writing. Wipe it dry.

4 Place the piece of paper on the back of the acrylic square.

5 Use the paint pen to write on the acrylic, using the stencil as a guide.

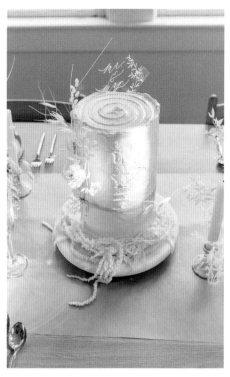

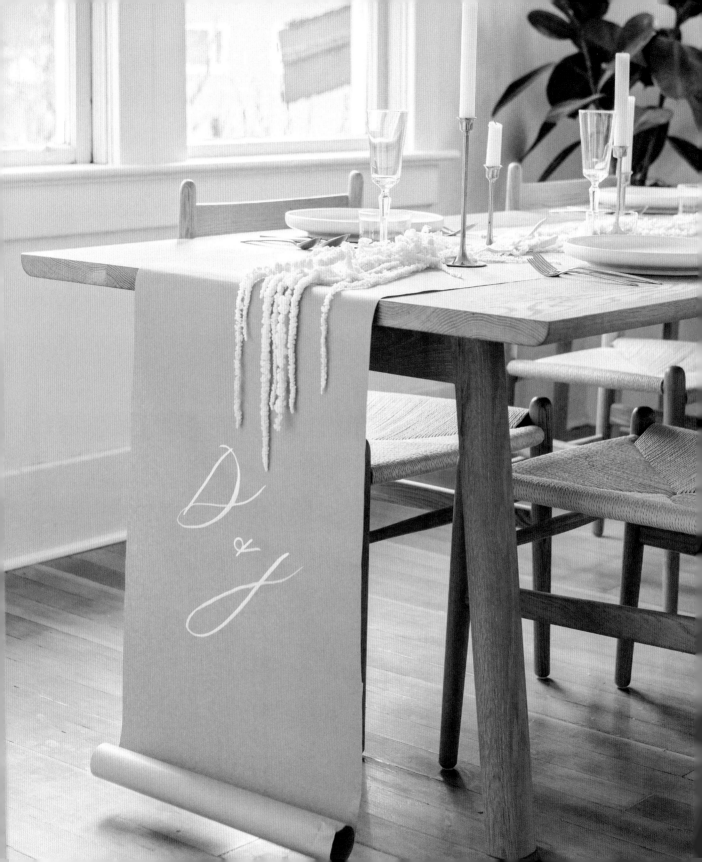

BESPOKE MONOGRAM AND
PLACE CARD TABLE RUNNER

I still remember stepping into my Aunty Madeline's house, welcomed by the delicious scent of food and flowers. She's such an amazing host and cook, and she had recently taken one of my calligraphy workshops and had used her newfound skills to create place cards for the settings, which were paired with a flower from her garden. What a beautiful way to make our meal so much more personal and memorable.

I don't often have events like these in my own home. I'm quite a simple cook and I love making easy, one-pot dishes! In that case, a personalized table runner is a stunning and minimal yet timeless way to complement your table. Imagine: a long kraft paper sheet that rolls off the edge of your table and hits the ground, with the monogram letters written on it on both sides, and each person's name written at the place setting. It's going to be a table to remember, and yet it's so easy to do! And because it's kraft paper, you can easily roll it up after your event and send it to the compost. If you're feeling creative, you can even add some freehand illustrations of loose florals or greenery to dress it up more. Otherwise, adding some minimal ceramic bud vases would definitely make a statement on the table. In this tutorial, you're going to learn how to do some brush lettering with a real watercolor brush. Because the writing is quite large, using a calligraphy pen, which usually has a maximum height of 2 inches (5 cm), would be hard to do.

+ Ruler or tape measure

+ Kraft paper roll

+ Scissors

+ Pencil (such as a 9H)

+ Scrap paper

+ Water

+ White gouache (such as Schmincke brand)

+ Dinky Dips or small-lidded containers

+ Round watercolor paintbrush (size 2)

+ Decorative faux flowers and branches (optional)

How To

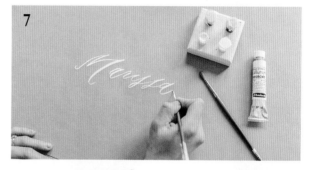

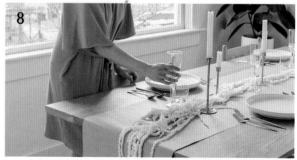

INSTRUCTIONS

1 Use a ruler or tape measure to measure the length of your table, as well as how long you would like the tails of the table runner to be. You can keep the runner hanging about 12 inches (30.5 cm) from the ground, or it could be really long with layers on the ground. Write the measurements down on a piece of paper.

2 Measure the kraft paper in the length you require for the table runner and cut it to size with the scissors. The table runner should be between 12 x 16 inches (30.5 x 40.6 cm) wide.

3 For the sides of the table you will be writing the monogram on, measure about 10 inches (25.4 cm) down from the edge of the table. This is where you will create the monogram in the next step.

4 To create a monogram, write it out in pencil first on a smaller sheet of paper. Re-create the monogram on the kraft paper using the pencil. Mix two parts water and one part gouache in a Dinky Dip to create the ink. Test it out on a piece of scrap kraft paper first, before writing on your runner. Then use the brush lettering techniques (page 9) to trace over your pencil outline with the paintbrush and white paint. Make the upstrokes light and the downstrokes thick, keeping in mind the bottom and top transition points.

5 Create the monogram again on the other end of the table runner.

6 Place the table runner on the table and set the table but keep the middle section clean, so that you can write the names of your guests.

7 Based on where you have positioned your guests, sketch out the person's name in pencil first, and then paint over the person's name using the paintbrush and white paint, closest to their table setting.

8 If desired, finish setting your table with the decorative faux flowers or branches to complete the look.

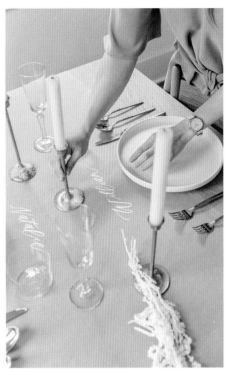

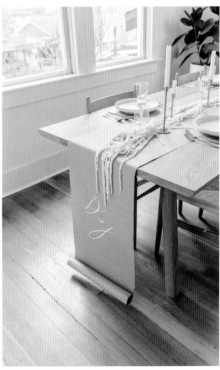

MONOGRAM SAMPLES

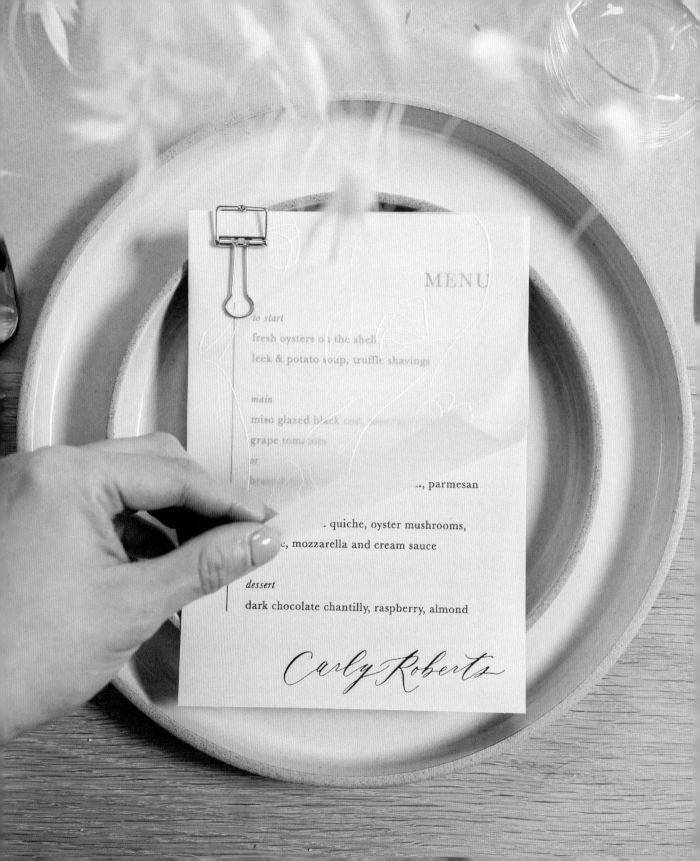

MENU

to start
fresh oysters on the shell
leek & potato soup, truffle shavings

main
miso glazed black cod,
grape tomatoes
or

, parmesan

quiche, oyster mushrooms,
, mozzarella and cream sauce

dessert
dark chocolate chantilly, raspberry, almond

Carly Roberts

SLEEK BOTANICAL PLACE CARD AND MENU

Adding menus to each place setting has become pretty standard these days for weddings and corporate and special events. Creating anticipation for what's to come adds excitement to the meal and allows the guests to enjoy the dinner—and the company of course.

Vellum is one of our favorite media to use here at the studio. We love the translucent and subtle effect it creates, and it often elevates the overall look of the menus. This menu will have an illustrated vellum overlay with a simple printed menu and a handwritten portion at the bottom for the guests' names. We juxtapose some handmade elements with printed elements, as calligraphy projects don't always have to be fully handwritten. And of course, adding the personalized effect of writing people's names makes these menus memorable. I can't wait for your guests to see these menus on their settings. Writing on vellum is really easy because it is a smooth surface. However, vellum doesn't absorb ink as well as paper; you'll need to make sure that you draw from left to right, so that you don't smudge the ink when you're drawing on the vellum. Otherwise, you'll just need to wait for the ink to dry!

+ White copy paper or scrap paper

+ Pencil (such as a 9H)

+ Calligraphy pen

+ Nib

+ White ink (such as Dr. Ph. Martin's Pen-White ink)

+ Vellum sheets cut into 5 x 6-inch (12.7 x 15.2-cm) pieces

+ Menu printed on 5 x 7-inch (12.7 x 17.8-cm) sheets of paper

+ Gold clips

+ Black ink (such as Best Bottle sumi ink)

How To

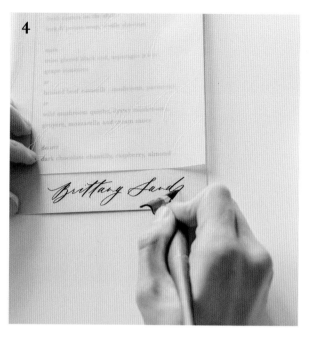

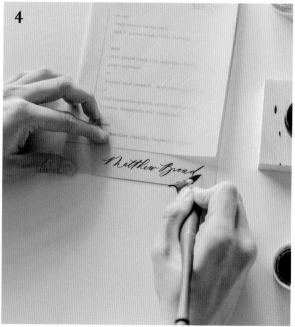

INSTRUCTIONS

1 Cut out a 5 x 6-inch (12.7 x 15.2-cm) paper and draw loose floral illustrations on it, then use it as a template for the vellum overlay. This way, you can see the illustrations and will be able to trace over them.

2 Fit the calligraphy pen with the nib. Use the white ink and calligraphy pen to trace the illustrations onto the first vellum sheet. Repeat the process until all the vellum sheets are illustrated.

3 Align the vellum sheets on top of the printed menus, then secure them by adding the gold clips. There will be a 1-inch (2.5-cm) space at the bottom of the menu where you may write the person's name using the black ink in the next step.

4 Use the calligraphy pen and black ink to write the names at the bottom of the menus. You can choose to write them left aligned or center aligned. If you would prefer to center them, make sure that you print out the names centered, with a 5-inch (12.7-cm) border, so that you can visualize where the text will need to be when you write them. Alternatively, you can start with a pencil outline first, making sure that it is centered, then trace over the pencil with the calligraphy pen and ink.

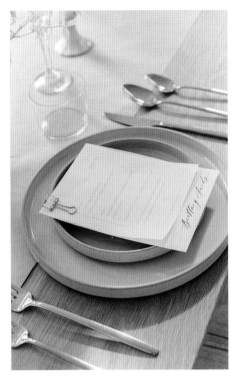

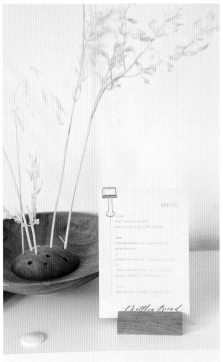

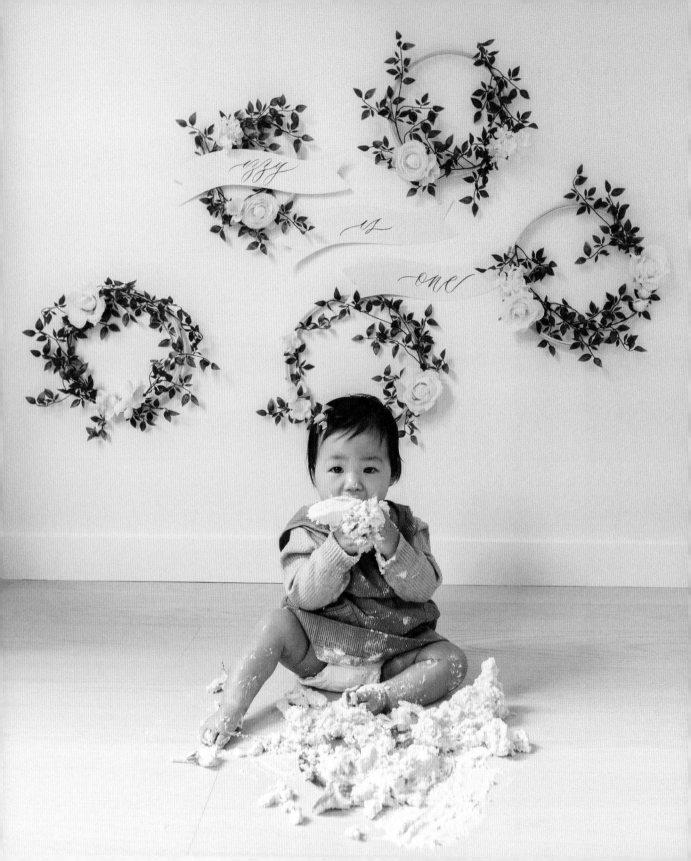

FLORAL HOOP BACKDROP

My niece was turning one and I was recruited by my sister (more like volun-told!) to help decorate the backdrop for the cake smash, as she wanted it to be extra special and personalized. Immediately, I thought of using calligraphy ribbon banners paired with embroidery hoops decorated with florals and greenery. Now that you are a calligrapher, you're definitely going to be asked to create something special, just like this, by your friends and family. There's just so much you can do with calligraphy!

In this project, you're going to combine a couple of crafting skills. First, you're going to exercise some flower-arranging skills to attach the foliage to the signs. Then you're going to make signage using calligraphy. To keep this project allergy-free, we purchased faux flowers from the local art supply store—that way, we can reuse these embroidery hoop wreaths for another project later on.

Supplies

+ Embroidery hoops in various sizes (such as 9, 10 and 12 inches [22.8, 25.4 and 30.5 cm])
+ Ruler
+ Pencil (such as a 9H)
+ 20 x 30-inch (50.8 x 76.2-cm) or larger sheets cardstock (Legion Stonehenge paper in Natural or similar)
+ Scissors
+ Black or gray brush pen (such as a Tombow Fudenosuke Hard Brush Pen)

+ Eraser
+ Faux flowers in one or two pastel colors
+ Faux vines
+ Wire cutters
+ Glue gun and glue sticks
+ Wire (optional)
+ Fishing line or nylon string
+ Tape

How to

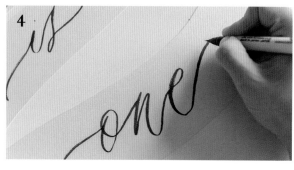

INSTRUCTIONS

1 Lay out the embroidery hoops based on how you are planning to hang them for your backdrop.

2 Select the hoops that you will be attaching signs to. Measure the hoops with the ruler. Using a pencil, draw three ribbon shapes on the cardstock paper that are at least 14 inches (35.6 cm) long. Cut out these shapes with scissors.

3 On the ribbon cutouts, write the words in pencil for tracing later.

4 Trace the pencil outline with the brush pen. When using a brush pen, keep the same techniques as calligraphy: Use light pressure while making the upstrokes, and add pressure to the brush while writing the downstrokes. Once the artwork is dry, erase the pencil marks with the eraser.

5 Snip the faux flowers and vines using the wire cutters and lay them out on the embroidery hoops.

6 Use the hot glue gun to adhere the greenery and flowers to the embroidery hoops. Start with the vines, then add the flowers one by one. Remember, less is more! Alternatively, you may attach the vines and flowers with the optional wire instead of the glue.

7 Once you are done adding all the vines and flowers to all the embroidery hoops, add the ribbon strips, using the glue gun, to the middle of some of the hoops to complete your signs.

8 Cut 1 yard (1 m) of the fishing line and tie one end to the hoop. Hang the other end of the fishing line above the hoops by securing it to the wall with the tape.

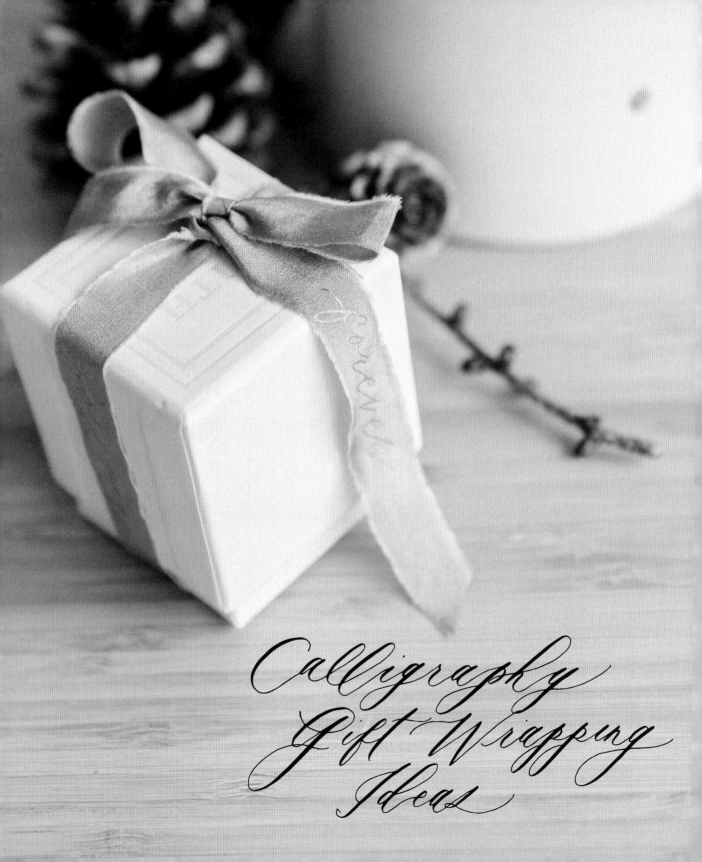

Calligraphy
Gift Wrapping
Ideas

Gift wrapping is one of my favorite things to do—aside from shopping for the presents, of course! The gift wrapping is the first thing that recipients see, so it's important to make a beautiful first impression. I love creating some unique packaging for my recipients—it adds to the overall experience of opening the present. Making things more personal, adding gift tags or creating illustrated gift wrapping paper combined with calligraphy has truly become a signature look for my gifts. I absolutely love it when people say, "I don't want to open the present because I'm afraid I'll ruin the packaging!" It builds anticipation for the gift inside that I've handpicked for them.

When I was five or six, I stumbled upon my mom's assistant, who was working overtime at the office, which was at our home. She was wrapping all of my mom's presents, as my mom cannot gift wrap—she still asks me to do it for her nowadays! I was enamored watching her folding and cutting the wrapping paper so nicely and tying the most beautiful bows on each gift. I begged her to teach me. She was so patient as I stumbled through my first few gifts. I spent hours in that office, wrapping and rewrapping the gifts, because I kept making mistakes. My mom was probably wondering where I was at bedtime, because I was definitely not in bed by 8 o'clock. After that night, I asked for more things to wrap and my mom gladly obliged. I became my mom's official gift wrapper. Over the years, I developed new styles and techniques to grow my arsenal of gift wrapping ideas. Are you excited? Let's learn how to incorporate calligraphy into your gift wrapping.

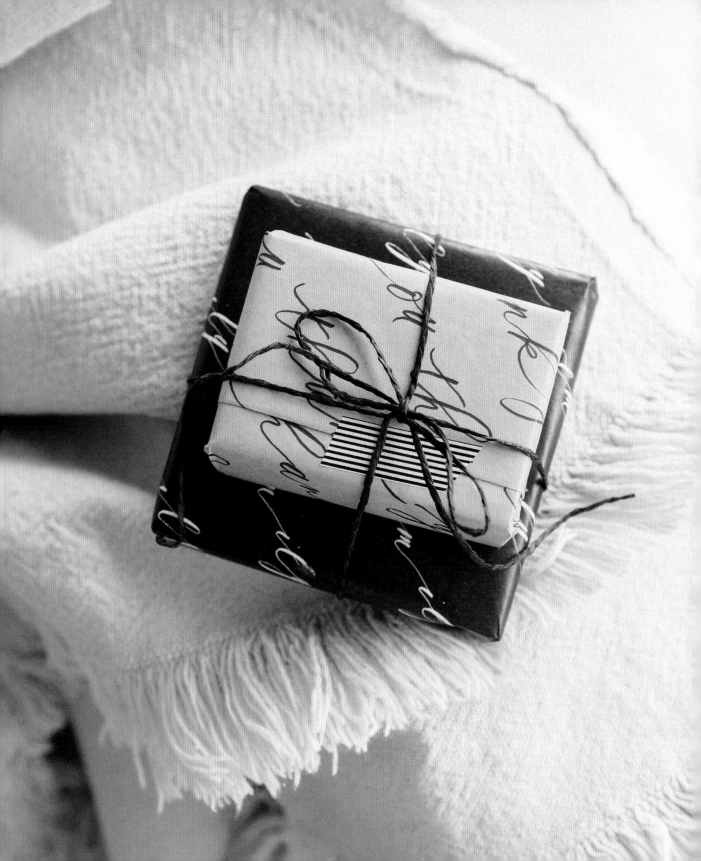

PERSONALIZED CALLIGRAPHY
GIFT WRAPPING PAPER

This project is a house favorite. It's something I've done plenty of times, and it makes such a statement that people immediately know when it's a gift from me. In this project, you will be creating gift wrapping paper with the phrase "thank you" written in a pattern, over and over, or you can choose to personalize the paper with the recipient's name! This way, you can even give the present without a gift tag. But a touch of ribbon won't ever hurt anybody, so I like to accessorize my gifts with some contrasting twine or ribbon.

The beauty of creating your own gift wrapping paper is that it is truly one of a kind, and there are many ways you can create the pattern. My go-to is a slanted repeated pattern, but a spaced-out horizontal pattern works as well. This one is so easy and you can even do it after the gift is wrapped!

+ Ruler

+ Scissors

+ Kraft paper roll, black gift wrap paper roll or white gift wrap paper roll

+ Calligraphy pen

+ Brause Steno Blue Pumpkin nib

+ Ink of choice (such as Dr. Ph. Martin's Pen-White or Dr. Ph. Martin's Iridescent Copper Plate Gold)

+ Tombow Fudenosuke Hard Tip Brush Pen or Pentel Arts® Pocket Brush Pen in black (optional)

+ Clear tape or washi tape

+ Ribbon or twine

How To

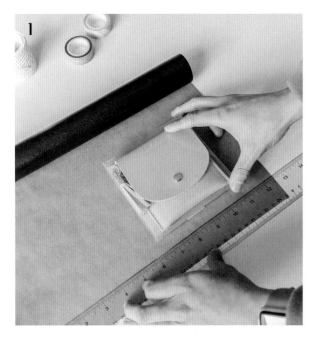

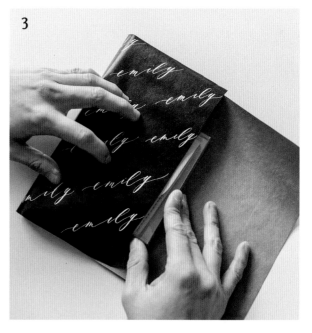

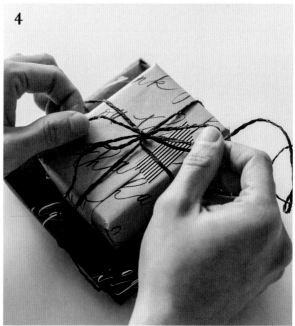

INSTRUCTIONS

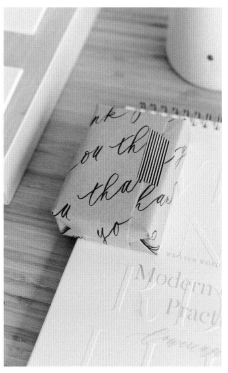

1 Use the ruler and scissors to measure and cut the gift wrap in the size required for your gift. Typically, you will need to measure a long rectangular sheet that is three times the width of your item, and about two times the length.

2 Fit the calligraphy pen with the nib. For a diagonal pattern, start writing the words "thank you" or the person's name using the calligraphy pen and ink on the top left corner on a 45-degree angle in a repeated pattern. Write the name or phrase at a maximum of 1 inch (2.5 cm) in height if you're using a calligraphy pen and ink. If you're working on a large gift, you can make the repeated pattern larger so that you're not writing forever. When you write letters taller than 2 inches (5 cm), you can use the Tombow Fudenosuke brush pen to write instead of the calligraphy pen; this will help the overall look of your letters. In the following line, leave a 2- to 3-inch (5- to 7.6-cm) gap so that there's some room between the lines.

3 For a horizontal pattern, start writing the words "thank you" or the person's name on the top left corner, leaving about a 2-inch (5-cm) space between each word horizontally. Leave a 1- to 2-inch (5- to 7.6-cm) space between the lines. Once you're done decorating your wrapping paper, wrap your present using the paper, securing it with the tape.

4 Add the ribbon for a finishing touch.

MODERN BRUSHED GOLD LEAF TAGS

Can you tell that I love the color gold? I think it's a timeless, elegant look that goes well with many occasions. One beautiful way to incorporate gold is to use gold leafing. It has an old-world feel that still is relevant and modern. In this tutorial, I'm going to share with you my passion for gold and how to add it to gift tags. And of course, they'll be in our signature, minimalist, modern style, which your recipients are going to love. Working with gold leaf is amazing. You're never quite sure how it will turn out, but the resulting artwork has this "curated messy" look that is so memorable. The best part of this project is that you can make lots of these gift tags, so you'll never have to buy any! You'll be channeling your inner abstract genius making these calligraphy tags in gold.

+ Paper cutter

+ Bristol paper

+ Scissors

+ Glue stick

+ Gold leaf sheets

+ Ruler

+ Large coarse paintbrush

+ Hole punch

+ Calligraphy pen

+ Nikko G nib

+ Gold ink (such as Dr. Ph. Martin's Iridescent Copper Plate Gold)

+ Twine or ribbon

How To

1

2

3

4
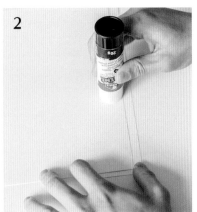

5
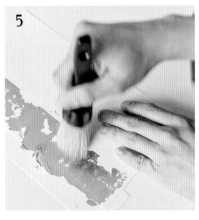

6

7

8

9

INSTRUCTIONS

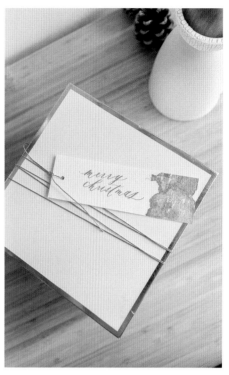

1 Use the paper cutter to cut out a 5 x 8-inch (12.7 x 20.3-cm) rectangle from the Bristol paper.

2 Using the glue stick, apply a lot of glue in a strip about 2 inches (5 cm) long on one of the long edges of the rectangle.

3 Remove a gold leaf sheet from the packaging and press it down on the glued section of paper, with the gold leaf side touching the glue.

4 Apply pressure to the gold leaf sheet to make sure that most of the gold leaf adheres to the paper. You may need to use a ruler like a squeegee to help adhere the gold leaf to the paper.

5 Slowly lift the gold leaf paper away from the Bristol paper. Use the coarse paintbrush to brush around the gold leaf. Some of the gold leaf will have a brushed effect while some may organically get removed, and that's okay. You may need to use your hands to add some of the gold leaf back—if so, do it slowly.

6 When you are happy with how the gold leaf looks, cut the Bristol sheet to produce 1-inch (2.5-cm)-wide tags with a bit of gold leaf at the ends.

7 Use the hole punch to make a hole on the one side of the gift tag.

8 Fit the calligraphy pen with the nib. Using the calligraphy pen and gold ink, add a greeting or the person's name to the tag.

9 Attach the tag to your gift with a piece of twine.

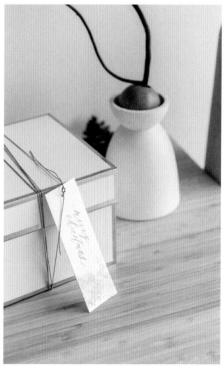

ELEGANT GOLD-FOILED SILK RIBBONS

I believe in balanced gift wrap design. If the gift wrapping paper is busy, then it calls for a simpler ribbon. On the other hand, if the gift wrapping paper is simple, then you can dress it up with some pretty ribbon. In this project, you're going to discover the wonderful world of hot foiling—specifically, gold foiling! Foiling is the process of using heat to adhere heat-activated foil to porous surfaces, such as wood, leather, fabric and paper. When you write on top of the foil with this heat pen, you will transfer the foil to the surface underneath. When you peel off the foil, you'll reveal the impression. Perhaps you have seen wedding invitations or business cards with gold-foil printing—those use a heated press and foil to create the impression. But a heat pen from We R Memory Keepers makes it possible to create freestyle illustrations on many different kinds of surfaces. Because calligraphy pens cannot write on fabric very well—and certain colors, such as gold, are harder to write with on fabric—hot foiling is a great alternative. It definitely has solved my problem of writing on ribbon. Once you learn this incredible skill, you'll be gold foiling every little thing.

+ We R Memory Keepers® Foil Quill™ fine tip heat pen and USB battery pack (see Tips and Tricks, page 111)
+ Ruler
+ Scissors

+ Heat-activated foil
+ Silk ribbon or any kind of flat fabric ribbon
+ Washi tape

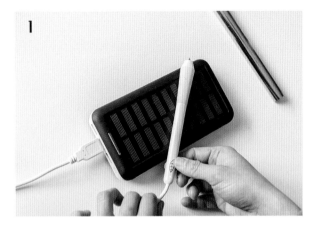

How To

1

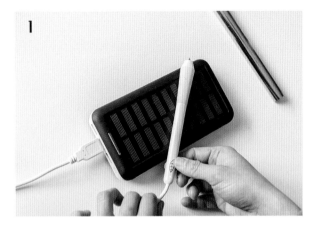

2

3

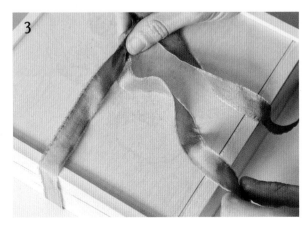

4

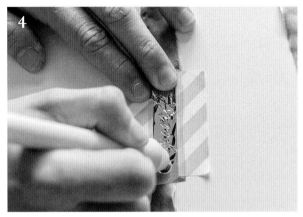

5

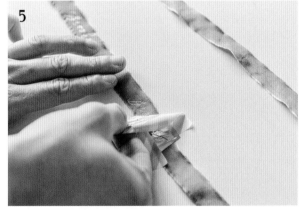

6

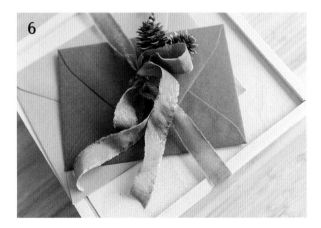

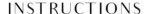

Tips and Tricks

+ This is a specific brand of heat pen that I tried and tested for this project. There are other heat pens, such as wood-burning tools, that may create a similar effect—you will need to ensure that it's at the lowest heat setting if you use another type of pen. I recommend this tool because it heats up to the right temperature for the foil to work.

INSTRUCTIONS

1 Plug the Foil Quill pen into a USB battery pack. Make sure the small white light at the bottom of the pen lights up. Let the pen warm up for about 5 minutes. Do not touch the tip, as it will be quite hot.

2 Using the ruler and scissors, measure and cut the foil into twelve (2 x 1-inch [5 x 2.5-cm]) strips.

3 Wrap the ribbon around your present and cut it to the appropriate length. Unravel it; this will be the length of ribbon you will be using for the project.

4 Place the foil on top of the silk ribbon and secure it with the washi tape. Using the Foil Quill pen and keeping the pressure even, write the recipient's name on the foil. As the tip is not flexible, you will only be writing this in monoline, outline format, just like if you were writing with a pencil. I do not recommend thickening the strokes using the Foil Quill pen and ribbon, as the fabric may move slightly and you will not be able to see the final artwork until after you remove the tape.

5 Slowly remove the tape and foil from the ribbon. The foil should leave a scripted foil version of the person's name.

6 Leave 2 to 3 inches (5 to 7.6 cm) of space between each instance of the recipient's name and repeat the process again until you finish the ribbon length required for your gift. Finally, tie the ribbon around your gift.

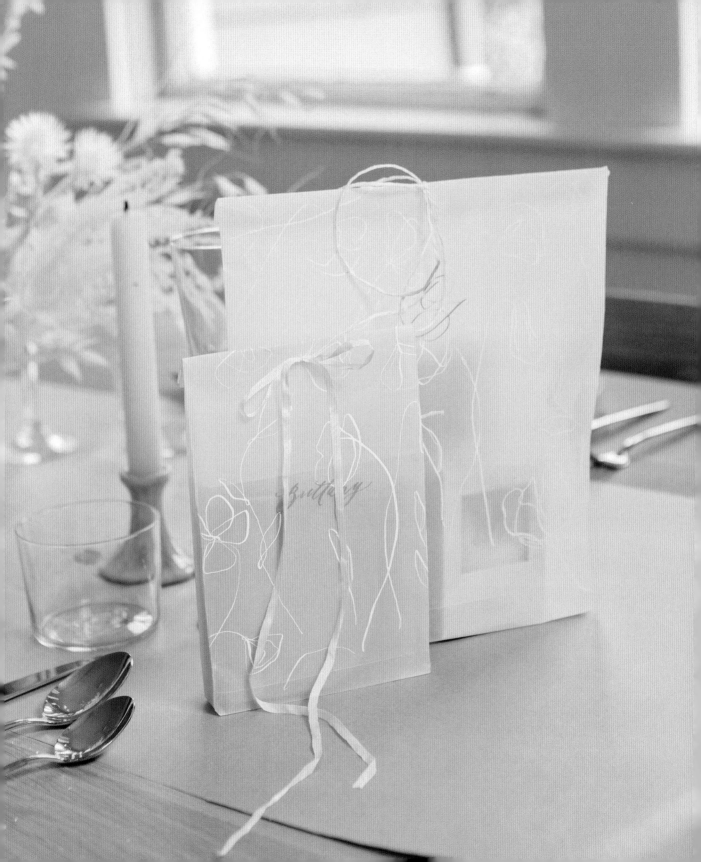

BOTANICAL VELLUM MONOGRAM GIFT BAG

To continue demonstrating my love for vellum, this project is going to be all about using vellum—this time as a gift bag that can also double as a favor bag. That way, when you have an event, everything will look cohesive, with a vellum seating chart, a vellum menu and a vellum gift bag. A vellum gift bag will give you a glimpse of what's inside it, but it doesn't entirely give away the surprise. Inside the translucent bag, you can still wrap the gift to make the unboxing experience even more complete. I love doing that as an extra touch. This project will teach you how to create a simple gift bag and add a touch of personalization by making a monogram and illustrated pattern throughout the paper, which will lend a modern, elevated feel to your present. This project will create one (8 x 10-inch [20.3 x 25.4-cm]) gift bag, so it's perfect for a small gift.

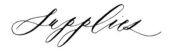

Supplies

+ Calligraphy pen
+ Nikko G nib
+ Floral template (refer to my website writtenwordcalligraphy.com/booktemplates or draw your own)
+ 11 x 17-inch (27.9 x 43.2-cm) translucent vellum sheet

+ Ink color of choice
+ Tape
+ Ruler
+ Hole punch
+ Scissors
+ Ribbon

How to

1

2

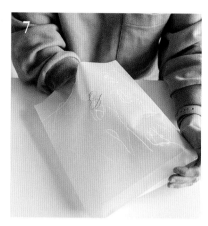

3

4

5

6

7

8

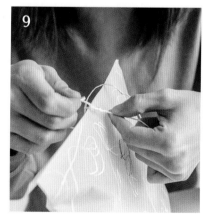

9

INSTRUCTIONS

1 Fit the calligraphy pen with the nib. If desired, you can download the floral template from my website or draw your own on a sheet of white paper. Place the template behind the vellum sheet and trace the illustration using the ink of choice. Alternatively, draw some abstract curvy lines across the vellum sheet, remembering that less is more.

2 Fold both ends of the vellum sheet to the middle and secure them with tape. Using the ruler, measure about 3 inches (7.6 cm) from the bottom and fold it up.

3 Open up the bottom end so that the inside of the paper is revealed.

4 Fold the top, bottom, left and right edges inward to create a rectangle.

5 Place two pieces of tape to seal the folds, so that you create the bottom of the bag.

6 Flip the gift bag to the other side. Write the recipient's name or monogram in the middle.

7 Place your gift in the bag and fold the top inward.

8 Use the hole punch to punch two holes at the top of the bag.

9 Using the scissors, cut the ribbon to the desired length. Insert the ribbon through the holes and tie it into a bow to complete the look.

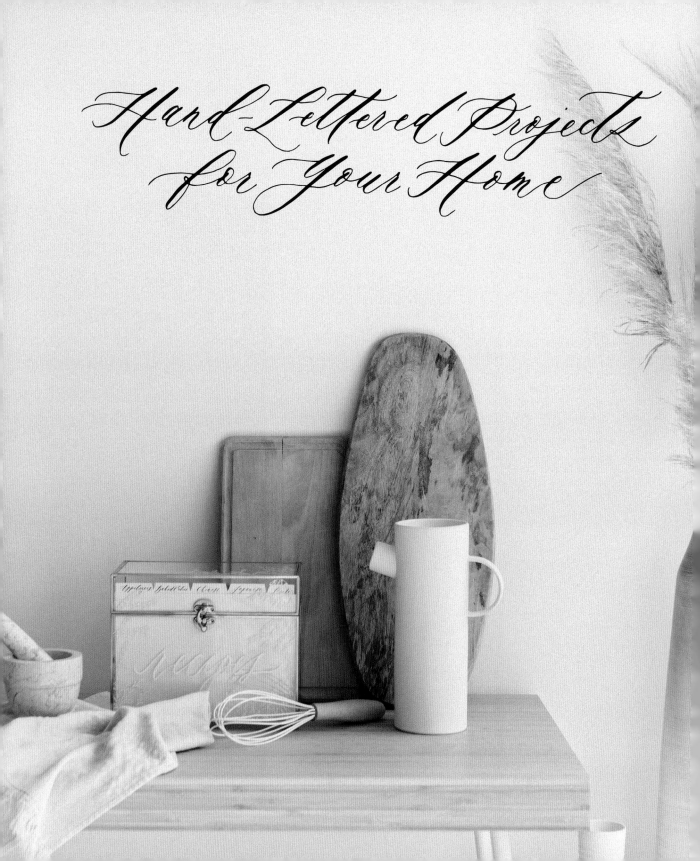

Hand-Lettered Projects
for Your Home

Calligraphy is an art meant to be displayed and appreciated. Something handwritten and handmade always makes a house homier and more welcoming. If you ever happen to walk through my parents' house, it's filled with my artwork from over the years, including from my childhood. Walls filled with drawings and sketches from my travels all over Europe, quotes from various seasons of our lives, signages that we've made for events my parents have hosted—my parents can't seem to let go of my work. I feel honored that they love to adorn their home with it.

In this section, you're going to create amazing projects, like my favorite: the Illustrated Blooming Wooden Perpetual Calendar (page 131). You'll get to exercise some sketching skills to draw flowers for every month, and couple that exercise with some simple woodworking! And of course you'll get to make some special touches, like quotes for the wall, labels for your pantry and memory shadow boxes, which are going to be remembered for a lifetime.

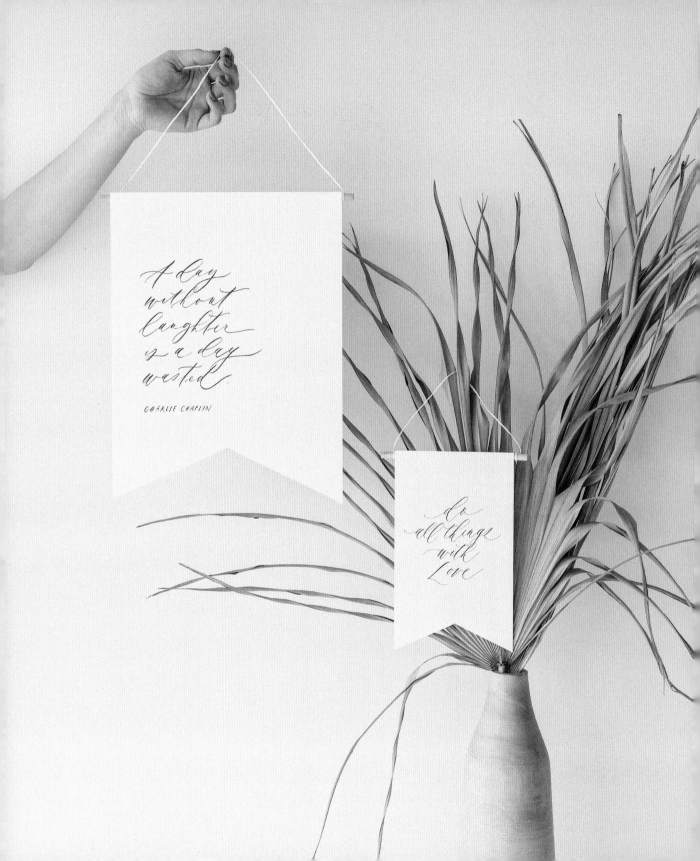

WALL-HANGING WOODEN CALLIGRAPHY PENNANT

My mom gifts many of my quotes to her family and friends every year, and this one is a favorite of hers. Adding a wooden dowel and string makes the quote easier to hang, and it's in a neutral palette that works with most homes. For my baby shower, I made these pennants as favors for my friends for attending and showering my baby with love. Needless to say, they're going to be great for your home or as gifts to your friends too! The beauty of this project is that it's easy to change the size of the pennant, so you can have a wall full of your quotes in various sizes. Pairing a pennant with photos in picture frames is also a great way to make your wall collage even more special.

In this tutorial, you're going to learn how to create larger pieces of artwork and to couple them with some crafting skills to hang the quote on the wall.

Supplies

+ Scissors
+ Bristol paper
+ Ruler
+ Pencil (such as a 9H)
+ Calligraphy pen
+ Nikko G nib
+ Ink color of choice

+ Tombow Fudenosuke Hard Tip Brush Pen in black (optional)
+ Eraser
+ Glue gun and glue sticks
+ Wooden dowel in the desired length
+ String of choice (such as leather, lace, twine, ribbon)
+ Hook to hang the pennant

How To

1

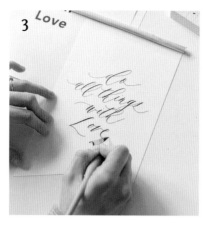

3 Love

6

2a

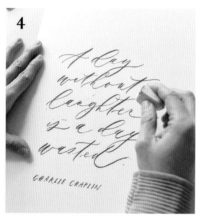

4

2b

5

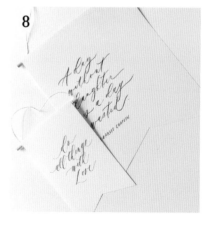

8

INSTRUCTIONS

1 Using the scissors, cut the Bristol paper into the size you want your finished artwork to be, with about a ½ inch (1.3 cm) margin on top.

2 Using the ruler, measure two lines to create an upside-down V from the bottom of the paper. Cut these lines with scissors to create a pennant tail.

3 Create a mock-up of your desired quote with the pencil. Fit the calligraphy pen with the nib, then trace over the mock-up with the pen and ink. Alternatively, if you are making a large pennant, you may write with the brush pen.

4 Wait for the ink to dry completely, then erase the pencil marks.

5 Plug in the glue gun and wait for it to heat up, about 5 minutes. Put hot glue across the entire top portion of the pennant, and then press the dowel onto the hot glue to adhere it.

6 Cut a piece of string in the desired length. Tie the string at both ends of the wooden dowel. Make sure that the string is tied tightly, then snip off the ends with scissors.

7 Put a bead of hot glue on the knots of the string to make sure it doesn't move from the dowel.

8 Finally, hang your beautiful artwork on the wall using a hook.

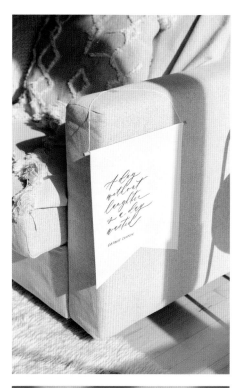

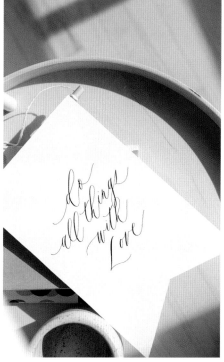

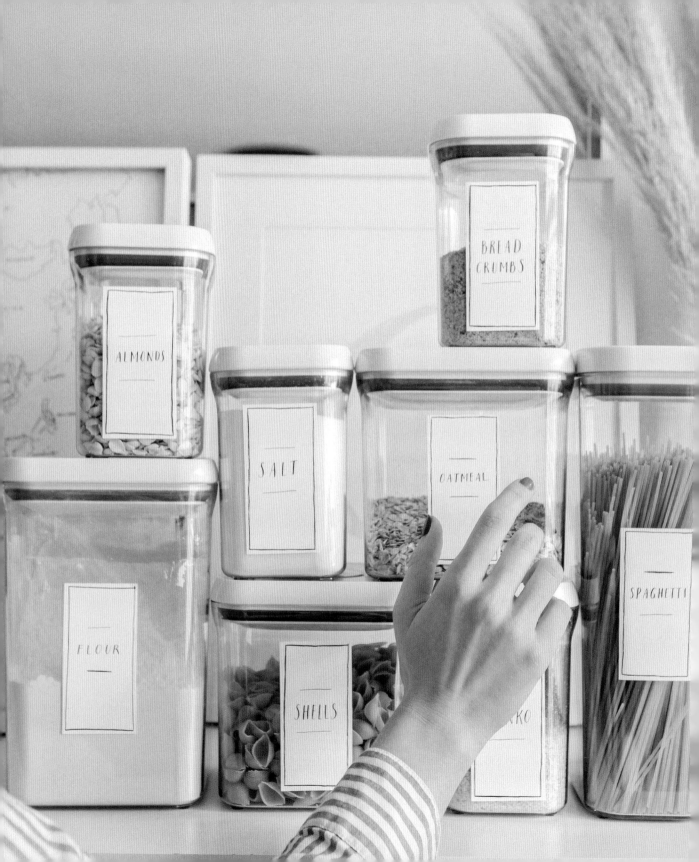

SIMPLE HANDWRITTEN
ORGANIZING PANTRY LABELS

This project came to be because a ton of my friends have recently gotten married and set up their own place. They've wanted to organize and start their home right. One of my very good friends and neighbor, Flo, is an organizing extraordinaire. I'm always impressed at how she keeps her house so tidy in spite of having two kids and two dogs. Her pantry is amazing. Everything is taken out of its original container and transferred to her streamlined container system. It's fantastic because she buys things in bulk, which reduces waste and is something I need to get started on as well.

For this project, you're going to learn a new style of lettering: block lettering! You'll make labels that you will stick onto containers so that you, too, can get organized. You can get creative and add some illustrations and borders, or you can keep it simple with just the label itself.

Block lettering is writing everything in uppercase, in print form. When you use a calligraphy pen and flexible pointed nib to create block lettering, you will automatically create thick and thin lines as you create downstrokes, upstrokes, curves and horizontal lines. You will use the same techniques as you use when you're writing in faux calligraphy. You will need to keep the downstrokes thick and the other strokes thin.

+ Ruler

+ Scissors or paper cutter

+ Label paper

+ Pencil (such as a 9H; optional)

+ Calligraphy pen

+ Nikko G nib

+ Ink of choice

How To

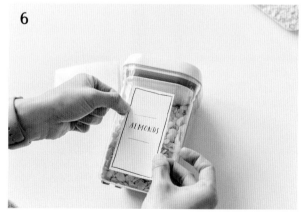

INSTRUCTIONS

1 Use the ruler and scissors to measure and cut 2 x 3½-inch (5 x 8.9-cm) rectangles from the label paper. If needed, use the pencil to mark the measurements prior to cutting.

2 Fit the calligraphy pen with the nib. Using the ruler as a guide, draw a 1-inch (2.5-cm) line about 1 inch (2.5 cm) from the top of the rectangle with the calligraphy pen and ink.

3 About a ½ inch (1.3 cm) below the line, write the item in the middle of the label using tall block letters. Keep the pressure as if you were writing in calligraphy, with the downstrokes heavy and the upstrokes light. You can refer to the suggested labels below for inspiration.

4 Draw another 1-inch (2.5-cm) line about a ½ inch (1.3 cm) below the tall block letters.

5 Draw a border around the rectangle using the calligraphy pen. It's okay to have imperfections in the border, as imperfection is part of the character of a handmade label.

6 Use the pantry label templates as a reference for the labels and write the item on each of the rectangles until you have completed your pantry.

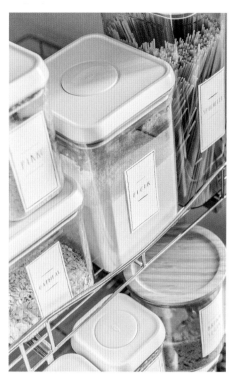

SUGGESTED LABELS

FLOUR

SUGAR RICE ALMONDS

BROWN COFFEE QUINOA
SUGAR

OATS TEA CEREAL

PANKO BEANS BAKING
 SODA

CHOCOLATE LENTILS BREAD SNACKS
CHIPS CRUMBS

PASTA FLAX SEED CORN
 STARCH

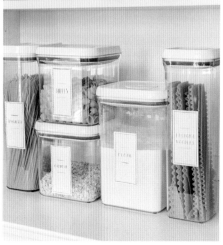

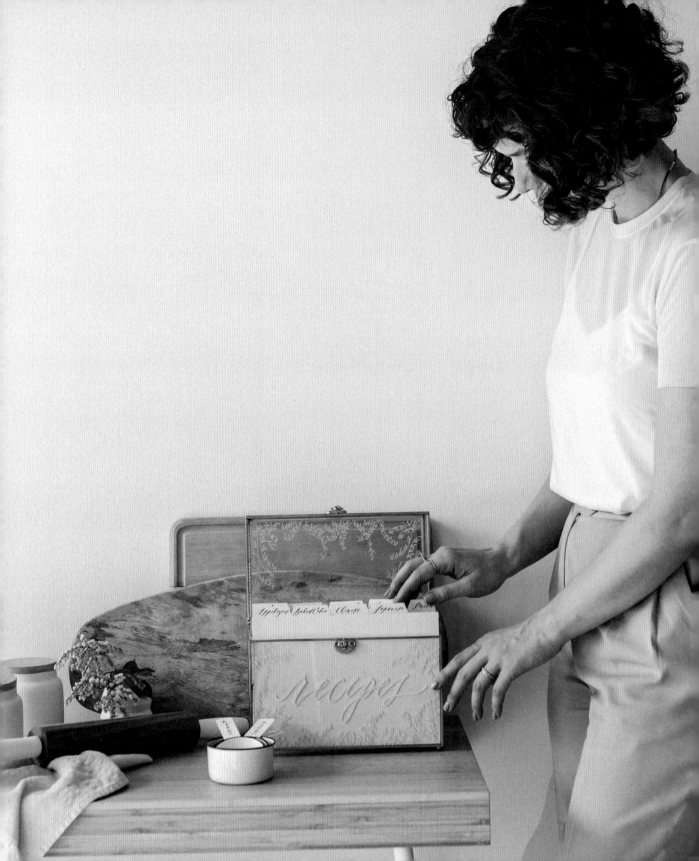

HAND-DRAWN GOLD GLASS RECIPE BOX
WITH ORGANIZERS

I've always loved recipe storage boxes because they hold those precious, well-worn recipes that bring warmth and comfort to my home. And of course, when you add a touch of calligraphy, it makes the box even more bespoke. My sister got me a special gift for my wedding: a collection of easy, 30- to 45-minute recipes for food that we grew up eating, and more! So I decided to purchase a gold glass box and reorganize my recipes in it.

In this project, you will be writing on glass again, this time on a keepsake box, and then you'll be making folders with calligraphy titles. This will help you organize your recipes accordingly. You'll be using both a calligraphy pen and markers in order to create this beautiful recipe box.

Supplies FOR RECIPE BOX

+ Gold glass display box
+ Rubbing alcohol wipes

+ White extra-fine tip oil-based paint pen (such as Craftsmart® or Sharpie® brands)

Supplies FOR ORGANIZERS

+

+ Ruler
+ Pencil (such as a 9H)
+ Scissors or paper cutter
+ 10 (8½ x 11–inch [21.6 x 27.9-cm]) sheets of cardstock in the color of choice

+ Calligraphy pen
+ Nikko G nib
+ Ink of choice

How To

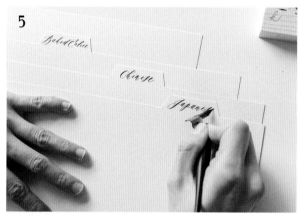

RECIPE BOX

1 Wipe the display box clean using the rubbing alcohol wipes.

2 Use the oil-based paint pen to write the word Recipes on the front of the glass box. Remember, this is a marker and not a calligraphy pen, so you will need to use the faux calligraphy techniques. Start off with the outline of the letters first, then shade the downstrokes, keeping in mind the bottom transition points and the top transition points.

3 Continue designing your box with florals, greenery, lines or whatever you like using the oil-based paint pen.

ORGANIZERS

4 Using the ruler, pencil and scissors, measure, mark and cut 7 x 9-inch (17.8 x 22.8-cm) cards from the cardstock in the number of categories you wish to create. Then cut out ½ x 1-inch (1.3 x 2.5-cm) tabs so that you can see the titles when the cards are all stacked together. These are going to serve as the dividers for your recipe box.

5 Fit the calligraphy pen with the nib. Write the title on the tab of each card using the calligraphy pen and ink.

6 To fill the recipe box with recipes, try printing the recipes on regular copy paper and folding them in half before putting them in the box.

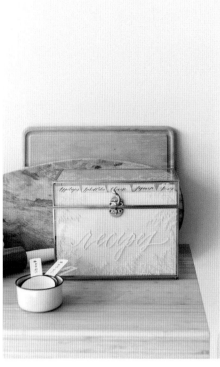

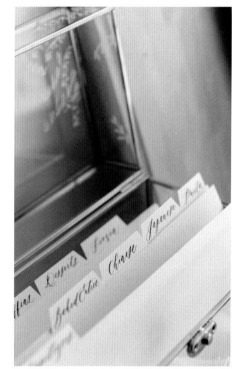

ILLUSTRATED BLOOMING WOODEN PERPETUAL CALENDAR

This is probably one of my most beloved projects! It combines so many of my favorite things, such as pushpins, botanical illustrations, calligraphy, walnut ink and wood. This project in particular is now a staple on my desk. I love gifting a calendar too! A perpetual calendar is a calendar that can be used year after year, but you can also get creative and change up the artwork every year. You'll have a chance to build the month, day, day of the week and the illustration per month too. I have selected numerous botanical illustrations that are known to bloom in every month to keep things unique.

Supplies

+ Paper cutter or scissors
+ Bristol paper or colored cardstock of choice
+ Pencil (such as a 9H)
+ Calligraphy pen
+ Nib of choice
+ Tom Norton Walnut Drawing Ink®

+ Dinky Dips or small-lidded container
+ Eraser
+ Binder clips
+ Wooden canvas block at least 10 x 8 inches (25.4 x 20.3 cm) in size and 1 inch (2.5 cm) deep
+ Pushpins

How to

4

5

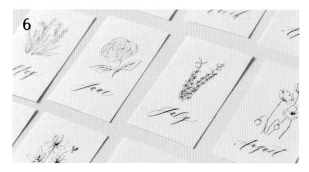

6

7

8

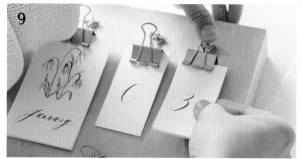

9

10

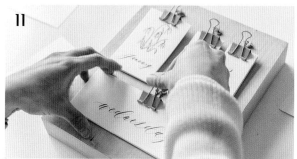

11

INSTRUCTIONS

1 For the month illustrations, use the paper cutter to cut out twelve (2 x 3-inch [5 x7.6-cm]) cards from the Bristol paper.

2 For the dates, use the paper cutter to cut out fourteen (1½ x 2½-inch [3.8 x 6.4-cm]) cards from the Bristol paper.

3 For the days of the week, use the paper cutter to cut out seven (5 x 2-inch [12.7 x 5-cm]) cards from the Bristol paper.

4 For the month illustrations, start by sketching the illustrations in pencil according to the month templates, which are available on my website (see Resources on page 170).

5 Fit the calligraphy pen with the nib. Place some walnut ink in a Dinky Dip. Trace over the pencil sketch using the calligraphy pen and walnut ink. After you are done tracing and the ink is dry, erase the pencil marks.

6 At the bottom of each month card, use the 1-inch (2.5-cm) space on which to write the months. If desired, you can write the months in pencil first and then trace over the names with ink afterward.

7 For the days of the week, write out the words in pencil, using the day templates that are available on my website (see Resources on page 170). Then trace over them with ink.

8 For the dates, there will be two sets of cards. One set will be for the first digit, and the second set for the second digit. Write the numbers in pencil, using the number template available on my website (see Resources on page 170), then trace over them with ink.

9 Using the binder clips, collate all the items onto the wooden canvas block. The months should have one set—twelve cards in total. The dates should have two sets. The days of the week should have one set.

10 Attach the four pushpins to the board to hang the binder clips.

11 Clip the months, dates and days to the binder clips, and change them as the days pass by.

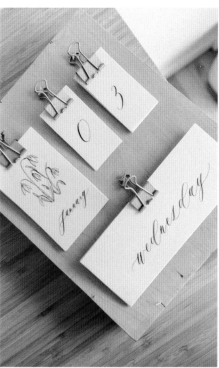

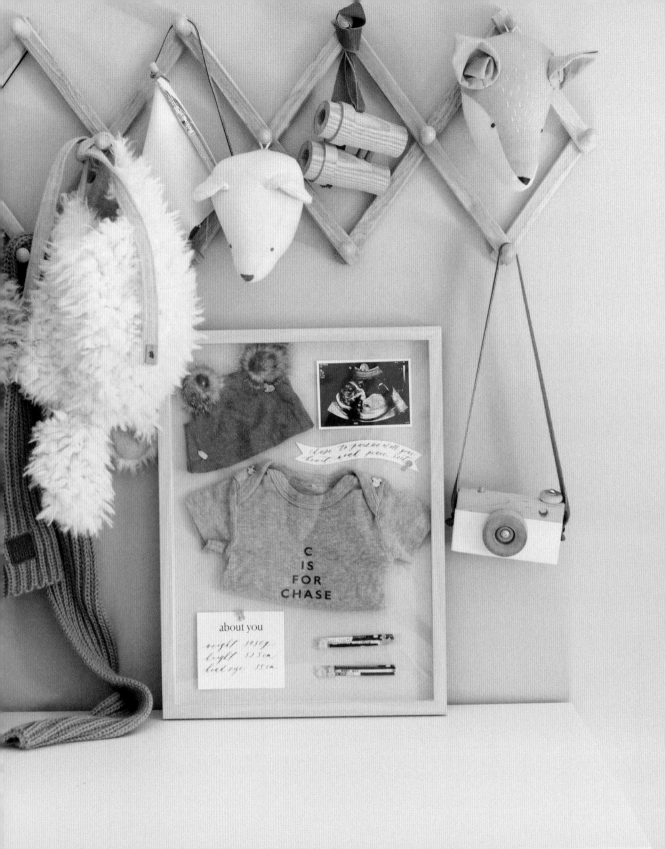

MINIMAL BABY MEMORY SHADOW BOXES

When I had my little one, my first few months were such a blur that I never got the chance to create a shadow box for him, so here I am, finally making one for my son! It was fun to reminisce about the memories of when he was so, so tiny, and looking at his first onesie brought tears to my eyes.

To make this project happen, you'll be combining some of the memorabilia with calligraphy accents. So, have some fun collecting these precious memories, and we'll be adding signs to each section, written in calligraphy. Whether you're going to be making this for yourself, for your friend's little one or for your niece or nephew, it will be such a memorable item that you will want to keep. Can't wait to see what you come up with!

Supplies

+ Shadow box or deep picture frame (see Tips and Tricks)
+ Ruler
+ Foam board
+ Knife
+ Paper, fabric, adhesive vinyl or background material of choice
+ Scissors
+ Double-sided tape, glue stick or stapler (optional)

+ Calligraphy pen
+ Nib of choice
+ Bristol paper and other colored cardstock
+ Ink of choice
+ Memorabilia pieces (such as ultrasound pictures, hospital tags, baby's first outfit, baby's first rattle or toy, baby's first hair clippings)
+ Pushpins, binder clips or washi tape

Tips and Tricks

+ For this project, I used a Hovsta frame from IKEA.

How to

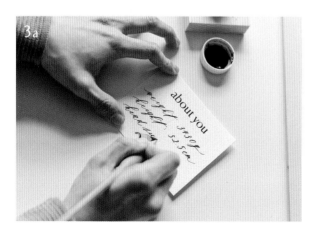

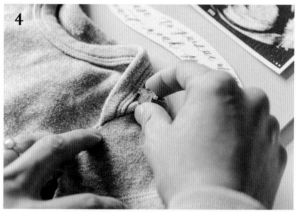

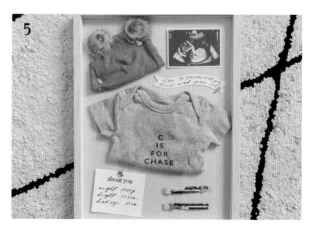

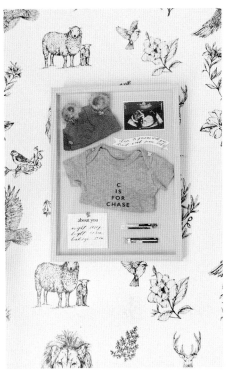

INSTRUCTIONS

1 Open up the shadow box and remove the mat. Use the mat as a template to measure the foam board and the background material of the frame with a ruler. Cut the foam board using a knife in order to fit it inside the shadow box. Cut the background material with scissors.

2 Attach the background to the foam board using the following methods, depending on the material: If you are using paper, secure it with double-sided tape or a glue stick. If you are using fabric, staple it to the foam board. If you are using adhesive vinyl, remove the backing and stick the vinyl on the foam board.

3 Fit the calligraphy pen with the nib. Cut out pieces of Bristol paper and use the calligraphy pen and ink to write on the paper. Before you attach the papers and memorabilia pieces to the foam board, lay them out on the background and plan where each piece will go, including the pushpins.

4 Once you have planned where everything goes, secure the paper and memorabilia pieces with the pushpins.

5 Finally, reattach the background of the shadow box frame and hang the shadow box on your wall or display it on your mantel.

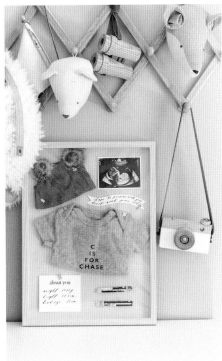

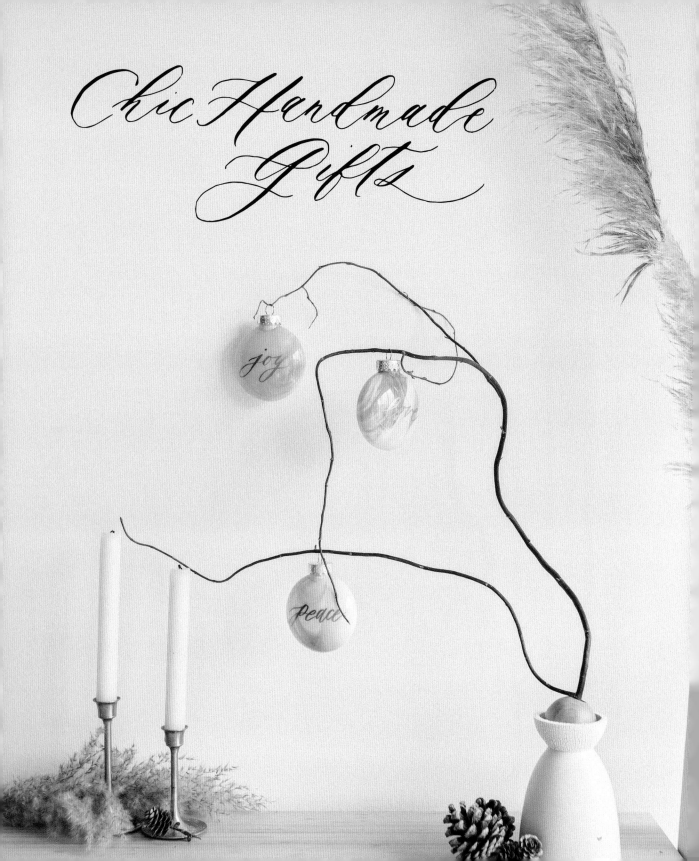

Chic Handmade
Gifts

I love making handmade gifts because sometimes you just can't find what your friend or loved one really needs. I'm one of those people who will scour stores for something special, gain some inspiration here and there and finally end up in the craft store, using a coupon to get some supplies. Then I head home to make the gift myself. Over the years, I have collected tons of crafting supplies that I use for projects. My assistant, Brooke, also has an arsenal of crafting skills that has complemented mine very well, so we often brainstorm to create fun projects together. In our families we're known for creating handmade gifts, so here are some ideas we've put together for you!

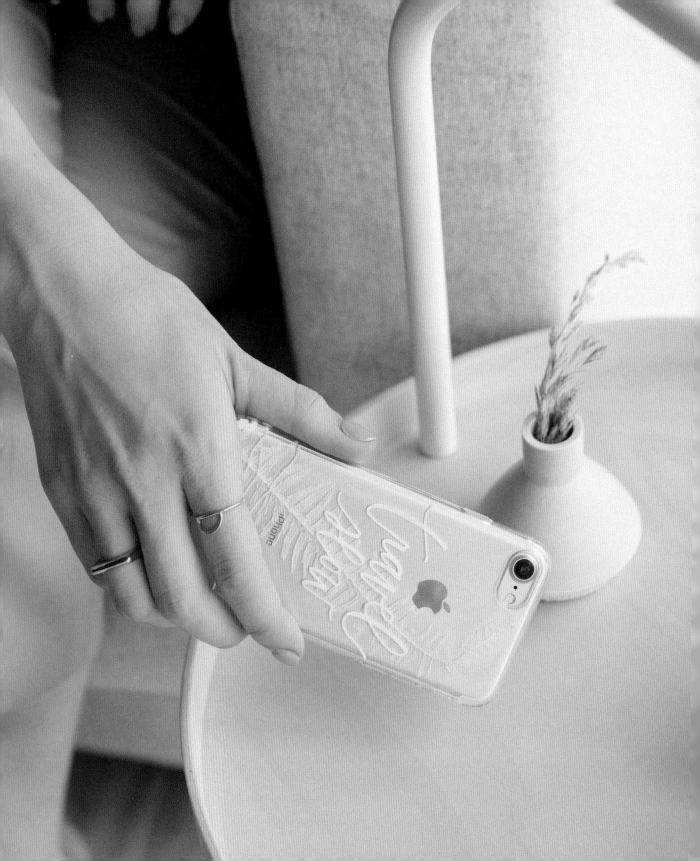

PRESSED FLORAL CALLIGRAPHY PHONE CASE

Because phones are being built with larger and larger screens, having a case on your phone has become pretty much mandatory. I've never been much of a case person, but because my cases have saved my phones so many times already, I know that I really can't live without them. What's fun about cases is that they can be changed easily to reflect my mood, style or even my outfit for the day. A unique phone case is a cool way to express yourself and to personalize your phone, especially because so many of us have the exact same model. I love this project because it makes a good gift to give to a friend—and to yourself too! Clear phone cases are quite reasonably priced and decorating them with a quote is really easy to do. If you get tired of your case or the quote needs to be changed, well, then, it's no problem to refresh it.

In this tutorial, you're going to learn two different ways to decorate your phone case with calligraphy and other materials. The second method is more permanent and more complex because it uses dried, pressed florals and resin, yet it's beautiful all the same.

+ Parchment paper

+ Tape

+ Pressed, dried flowers in a maximum of 3 colors

+ Scissors (optional)

+ Glue

+ Clear phone case in the appropriate size

+ White acrylic paint pen (such as Molotow or Montana brands)

+ Package of quick-dry resin

+ 2 plastic cups

+ Fine tip Sharpie Oil-Based Paint Marker in black

+ Craft sticks or disposable chopsticks

+ Cotton swab and acetone (see Tips and Tricks, page 143)

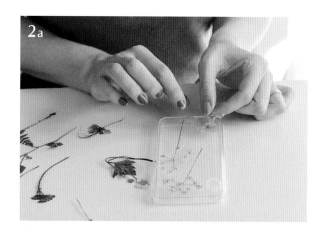

2a

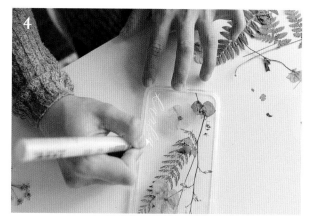

4

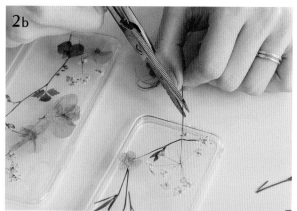

2b

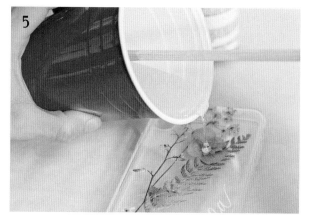

5

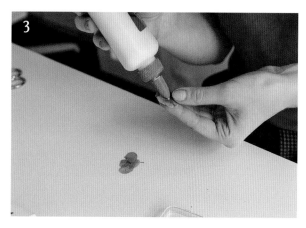

3

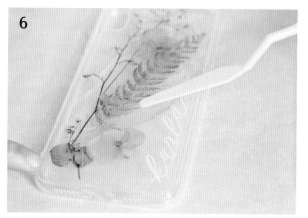

6

INSTRUCTIONS

1 Prepare your workspace. Secure a large sheet of parchment paper to your table with the tape.

2 Arrange the dried flowers to create an example layout. If needed, use scissors to cut stems of flowers and leaves as you lay them out. Once you are happy with the floral placement, take a photo of it as reference.

3 Glue the items onto the outside of the phone case one by one, using the photo as reference. Ensure every piece is glued down as flat as possible; otherwise, the leaves or florals will stick out when you pour the resin. Add a bit more glue and apply pressure if you feel like the florals are sticking out.

4 Use the acrylic paint pen to write calligraphy directly on the phone case.

5 Read the instructions on the package of resin. The product I chose involved measuring a 1:1 ratio of the hardener and resin, mixing the combination together and stirring for 3 minutes. I used two plastic cups, and I used a permanent marker to indicate how much I put into the cup. Don't worry about the bubbles that may surface—they will go away once you put the resin on the phone case.

6 Pour a little resin onto the case with the florals facing upward. Use a craft stick to spread the resin. Err on the side of caution, because it is much better to have too little resin than too much. Let the resin dry completely, 5 to 8 hours. Once it's dry, your phone case will be ready for use. The resin is durable and it won't break off. If your phone gets dirty, simply wipe it clean.

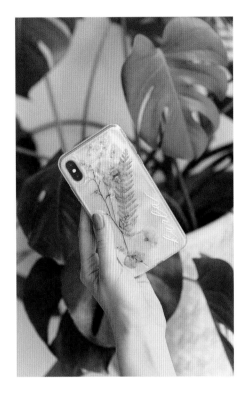

Tips and Tricks

+ If you end up with some spillover, do your best to move your case as little as possible. Dip a cotton swab into the acetone and slowly wipe it. Be extra cautious on the spots close to the camera holes, as you don't want any resin to get into those holes.

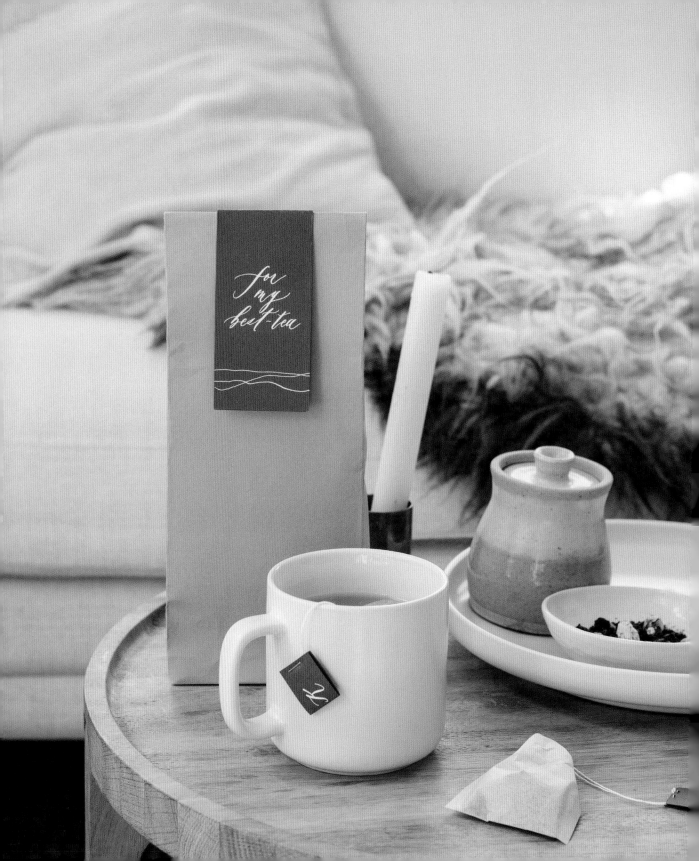

MONOGRAMMED HANDMADE TEA BAGS AND GIFT BAGS

Here's another favorite gift idea! Everyone in my studio is a tea lover, so we have our own stash of teas in the cupboard. This wonderful gift idea is fun and also super economical. It's far cheaper to purchase bulk loose-leaf tea, and disposable and biodegradable tea bags are very easy to get. What you're going to learn in this project is how to personalize and dress up some tea bags and to present them in a gorgeous bag as a gift. You can also choose the color scheme, based on the time of year, the recipient's favorite colors . . . you know the drill! There's an old-world charm to handmade tea bags and a handmade box to boot. I know your recipient is going to love this present.

+ Scissors
+ 8½ x 11-inch (21.6 x 27.9-cm) colored text weight paper
+ Scoring tool
+ Calligraphy pen
+ Brause Steno Blue Pumpkin nib
+ White ink (such as Dr. Ph. Martin's Pen-White ink)

+ Tea scoop
+ Unbleached tea bags
+ Loose-leaf tea
+ Stapler or double-sided tape
+ Tape
+ Colored cardstock

How to

1

2

3

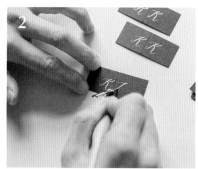

4

5

6

7

8

9

10

11

12

INSTRUCTIONS

1. Using scissors, cut the text weight paper into 1¼ x ½-inch (3.2 x 1.3-cm) sheets. Score the sheets in half.

2. Fit the calligraphy pen with the nib. Using the calligraphy pen and the white ink, create a monogram by writing your recipient's initials on both sides of the score. Repeat the process until you have created ten tags. Fold the tags in half.

3. Using the tea scoop, fill each of the tea bags with 1 scoop of the loose-leaf tea. Secure each bag by tightening the strings.

4. Use a stapler to attach the folded monogram sheets to the end of the tea bag strings.

5. Fold the text weight paper in the middle lengthwise. Tape it down.

6. Fold both sides of the bag inward about a ½ inch (1.3 cm). Then unfold them.

7. Fold the bottom of the bag ½ inch (1.3 cm) twice. Then unfold it.

8. Open up the bottom of the bag and fold it open.

9. Fold the top and bottom flaps down, and tape them together.

10. Insert your hand through the top of the bag to shape the bag. Place the tea bags inside.

11. Create a closing tag for the bag by cutting out a 2 x 7-inch (5 x 17.8-cm) sheet from the cardstock. Write the phrase "for my best-tea" using the calligraphy pen and white ink.

12. Secure the label using tape.

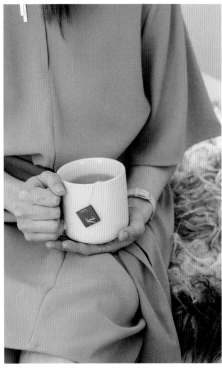

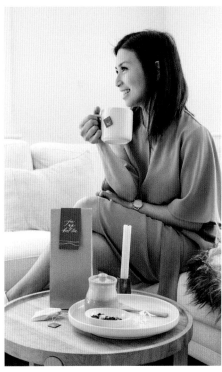

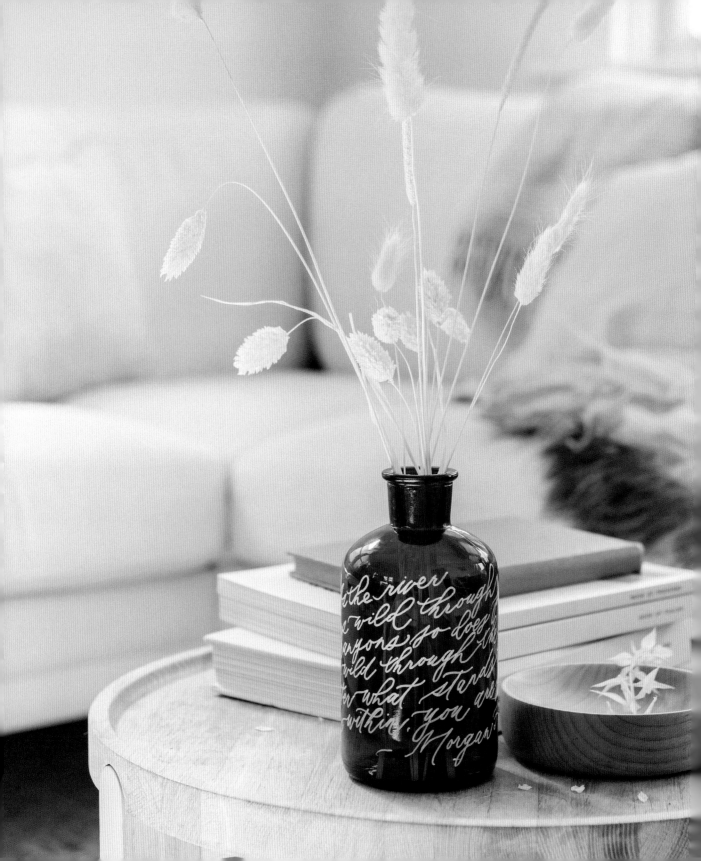

HAND-LETTERED AMBER BUD FLOWER VASE

Bud flower vases are such good decorative pieces. Every house needs a few of these! Personally, I love writing quotes and lyrics on them to make them even more special. In this tutorial you're going to learn how to write on curved glass—it's a bit tricky, but with some practice and some washi tape, you can certainly do it well! Hopefully, you'll be inspired to create some beautiful, personalized flower vases on your own and gift them to your friends and family.

+ Amber glass bottles (4 or 6 inch [10.1 or 15.2 cm])
+ Rubbing alcohol wipes or disinfecting wipes
+ White STABILO All pencil

+ Washi tape
+ White or gold extra-fine tip Sharpie Oil-Based Paint Marker
+ Fresh or dried florals or grass

How to

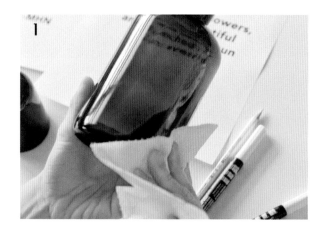

1

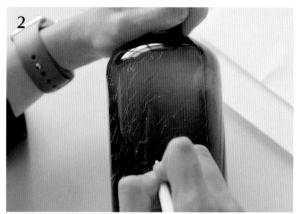

2

3

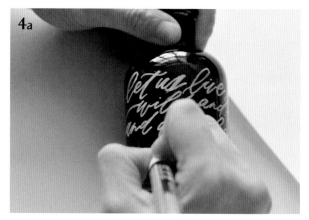

4a

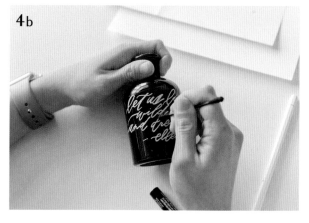

4b

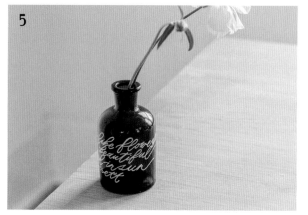

5

INSTRUCTIONS

1 Wipe the amber glass bottles with the rubbing alcohol wipes. Wipe the bottles dry.

2 Use the STABILO All pencil to sketch your desired quote on a bottle. Because the bottle's surface is curved, use washi tape to help you straighten the lines you will be writing on. Put the washi tape about a ¼ inch (6 mm) below the line you want to write, and use the STABILO All pencil to draw a line from the top of the washi tape. Then remove the washi tape, as when you start writing with the paint pen, you will have descender strokes, which will go onto the washi tape instead of the bottle. The STABILO All pencil is easily removable—you can use your fingers to rub off the sketch and redo it if needed.

3 Once you have finalized the layout for the quote, use the Sharpie Oil-Based Paint Marker to write on the bottle. Start with writing a monoline design, word by word.

4 Double the downstroke lines to create thicker strokes. Because this project is using the faux calligraphy technique, you will need to be cautious and taper off at the bottom transition point and create a smooth increase in thickness at the top transition point. Once you're done thickening the downstrokes of one word, go on to the next word.

5 Let the paint dry. Add some fresh or dried florals to complete the look.

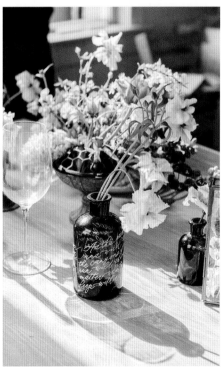

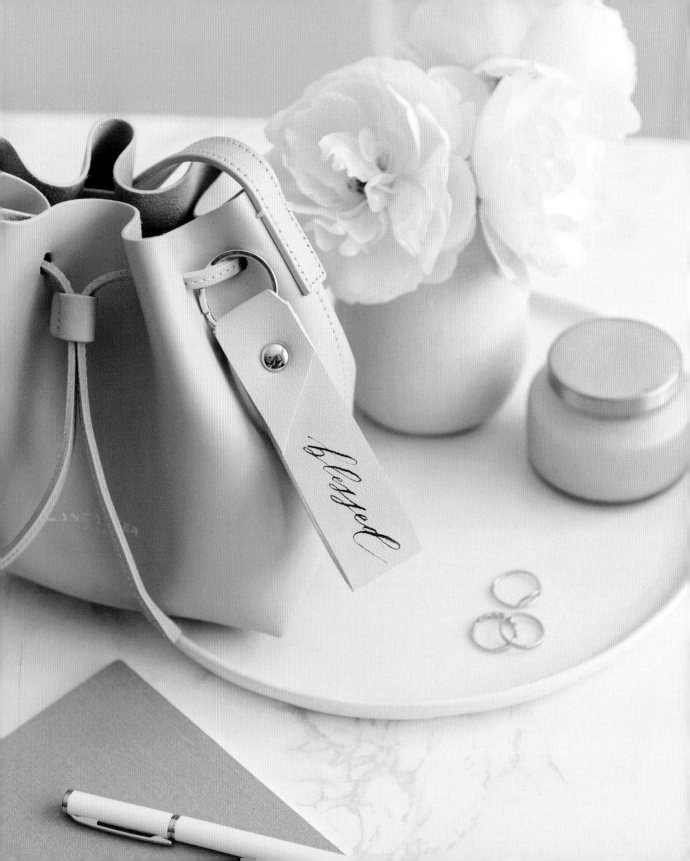

PERFECT LEATHER KEYCHAIN

Who enjoys the smell of leather? My team and I love it! Walking through the leather shop, touching and feeling each piece, perusing for the perfect leather for our little project sounds like a good start to the day. My assistant, Brooke, is an expert at working with leather and has given me lots of great tips I'd like to share with you for this project. This minimal keychain is versatile and an easy choice for a birthday or "just because" gift for a friend. This project is going to help you write on another kind of texture. Are you excited?

Supplies

+ 4 x 11–inch (10.1 x 27.9-cm) or larger piece of leather (see Tips and Tricks)
+ Pen in a color that shows up against the leather
+ Cutting mat
+ Rotary cutter or box cutter
+ Ruler

+ Hole punch or leather punch
+ 1-inch (2.5-cm) key ring
+ Chicago screws
+ Calligraphy pen
+ Nib
+ White acrylic ink (see Tips and Tricks)
+ Angelus Acrylic Finisher and paintbrush

Tips and Tricks

+ Find leather that is smooth in texture.
+ Acrylic ink works best for writing on leather surfaces.
+ Choose a name or short quote to write. Practice on a piece of paper before writing it on the leather.

How To

1

2

3

4

5

6

7

8

9

INSTRUCTIONS

1 On the back of the leather, use a pen to mark an 11 x 1¼-inch (27.9 x 3.2-cm) rectangle.

2 Cut out the rectangle on the cutting mat using the rotary cutter and a ruler.

3 On one of the edges of the rectangle, cut a diagonal line to create a slanted, modern edge.

4 Create a cutout for the key ring placement 1¾ inches (4.5 cm) from the slanted edge.

5 Fold the rectangle into thirds.

6 Use the pen to mark the placement of the hole. Use the hole punch to punch a hole through each layer of the leather.

7 To assemble the keychain, insert the key ring through the leather, align the holes and fasten the key ring with the Chicago screws.

8 Fit the calligraphy pen with the nib. Write a name or quote on one of the keychain's panels using the calligraphy pen and acrylic ink. You may practice on a small piece of leather to get used to how the ink flows on leather. You may need to go through some strokes twice to get a good result.

9 Apply a thin layer of acrylic leather finisher to seal the paint on the leather. This will help make it water resistant and protect the writing from scratches.

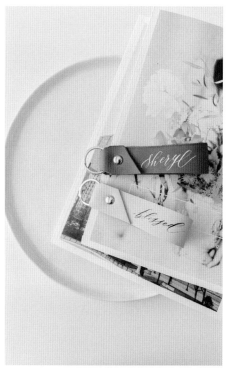

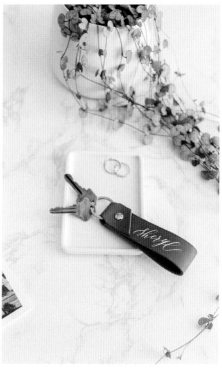

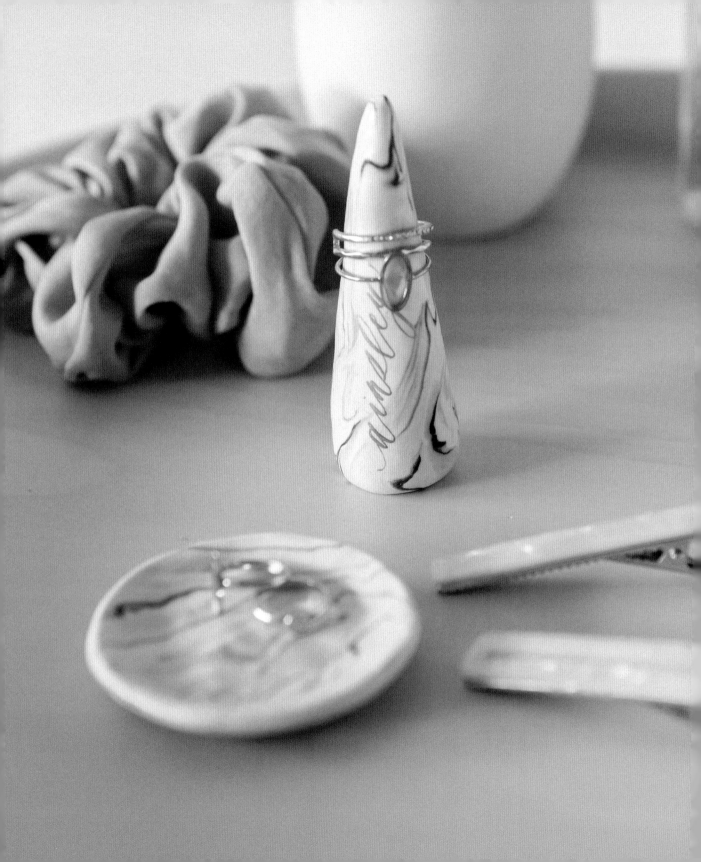

PERSONALIZED RING DISHES AND CONES

For my bridal shower, I made each of my lovely friends a set of ring dishes, and since then I've been known for making these marbled and personalized ring dishes. They're easy to make, I promise! I fell so deeply in love with the versatility of polymer clay that I decided to pick up pottery, which I realized is so much harder to do and requires many more materials than polymer clay. With polymer clay, you can make these dishes in the comfort of your own home, bake them in your oven and design or personalize them without much work or investment. Of course, polymer clay has its limitations, such as not being food-safe, but for ring and trinket dishes, you don't need them to be food-safe and typically you will not need to wash them. It really does make your Play-Doh childhood dreams come true.

Another great thing about polymer clay is that it's quite easy to personalize and glaze as well. You won't need much—just a pen and ink and a brush-on glaze will make everything permanent. You can also change it up and use the We R Memory Keepers Foil Quill pen to write on this material, as it is still quite porous. In comparison, it's really hard to use hot stamping on real ceramic; it will require a different method altogether.

Supplies

+ Polymer clay (such as Sculpey® III clay in pale pink, white and black)
+ Parchment paper
+ Calligraphy pen
+ Brause 361 Blue Pumpkin Nib
+ Gold ink (such as Dr. Ph. Martin's Iridescent Copper Plate Gold)

+ Pentel® Paint Marker or Sakura Pentouch paint marker in gold
+ Paintbrush
+ Polymer clay glaze in gloss finish (such as Sculpey brand)

How To

1

4

8b

2a

5

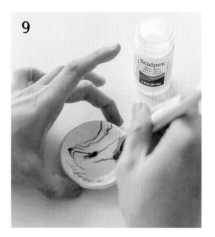

6

2b

8a

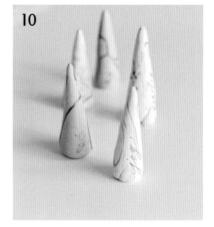

9

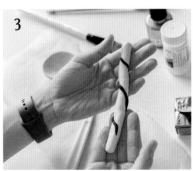

3

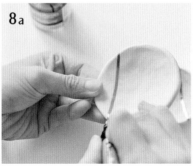

10

158 CREATIVE CALLIGRAPHY MADE EASY

PALE PINK CLAY

1 To prepare the pale pink clay, form a 1-inch (2.5-cm)-diameter ball of pale pink clay. Use parchment paper as your working surface to help protect your table top.

2 Knead the clay with your hands for 2 minutes to make it softer and more malleable. Move the clay in a circular motion to roll it up into a ball, then roll it between your palms in one direction to make it longer. Fold it together and start again. Note that you will need to knead the clay into the shape right after you prepare the clay—otherwise, it will cool down and dry.

MARBLE CLAY

3 To prepare the marble clay, form a 1-inch (2.5-cm)-diameter ball of white clay. Tear off a tiny pinch of black clay from its block. Knead the white clay for 2 minutes and then the black clay for 2 minutes. You will need to create two cylinder shapes: one from the white clay and one from the black clay. Roll the black clay around the white clay, just like a candy cane.

RING DISH AND CONE

4 To make a ring dish, roll the clay back into a ball when it is malleable. Use your thumb to press down in the middle and slowly work your way around the clay.

5 Press the dish evenly so that you create an organically shaped ring dish. You will want to keep the ring dish fairly thin, about a ⅓ inch (3 mm) in thickness.

6 To make a ring cone, roll the clay into a ball. Instead of keeping your hands parallel, create the cone shape with your hands at an angle, like a teepee. Then shape the cone and the bottom so it resembles a cone shape.

7 Bake the ring dish and cone on parchment paper according to the package instructions. Ring cones will usually need about 5 minutes more than ring dishes. Take the clay out of the oven and let it cool.

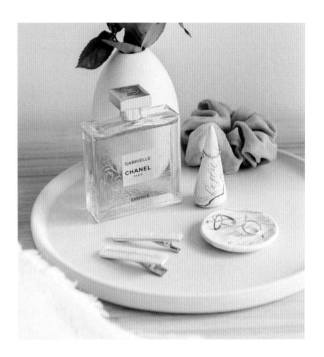

PERSONALIZING THE RING DISHES AND RING CONES

8 Once the clay is completely cool, you can add your personalization with the calligraphy pen fitted with the nib and ink, and the gold paint pen, to customize the ring dish and cone. Writing on polymer clay isn't hard—the surface is quite smooth and ink glides onto it easily.

9 After the ink is completely dry, use the paintbrush to gently apply two coats of the polymer clay glaze to seal the dish and cone and to create a glossy look. Make sure the clay is completely cool and the ink completely dry before you add the glaze. If you do it too soon, you might smudge the ink.

10 Create various sizes of ring dishes and cones and stack them up for a lovely, personalized gift for a friend.

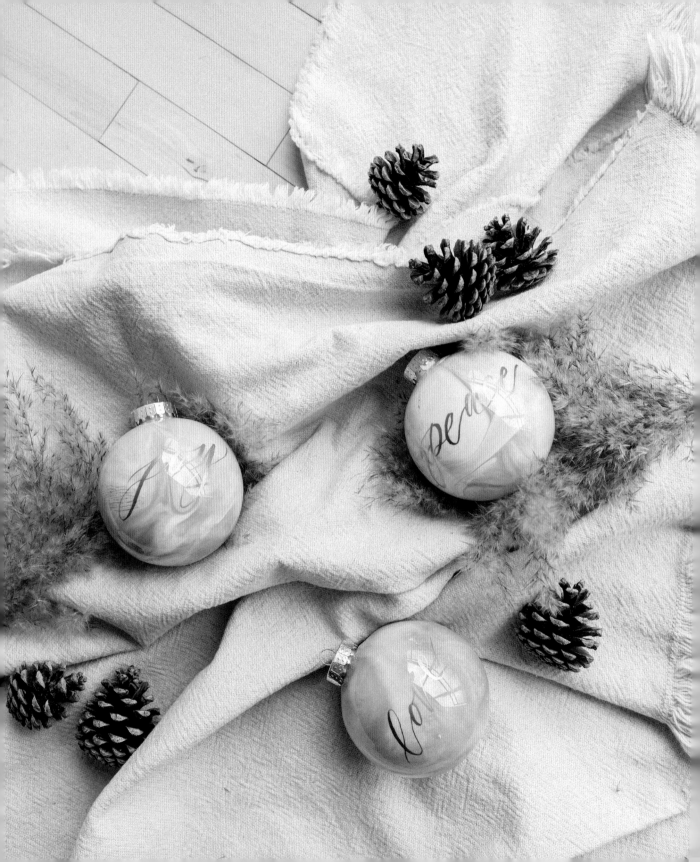

MARBLED CHRISTMAS ORNAMENTS

Oh, for the love of ornaments! My very good friend and business partner, Heather, is incredibly obsessed with ornaments—she's a self-proclaimed ornament hunter and is always on the hunt for unique ornaments from all over the world. This year, I decided that I would make some ornaments for her! This tutorial will teach you how to create a beautiful marbled effect to these ornaments, using a color scheme that you're going to love and remember.

A lot of us have fond memories of how we spent Christmastime during our childhood, and it's these personalized, memory-keeping ornaments that truly are the best kind—they tell stories that remind us of our family, and the year that it was founded or made. This simple little project to create your own ornaments is beautiful and creative and will hopefully remind you of a memory of the Christmas that that ornament was made.

+ Acrylic paints in colors of choice (see Tips and Tricks, page 163)

+ Clear Christmas ornaments

+ Plastic cups

+ Martha Stewart Crafts® Multi-Surface Marbling Medium

+ Craft sticks or chopsticks

+ Egg carton

+ Sakura Pentouch paint marker in gold

+ STABLIO All pencil (optional)

How To

1

2a

2b

3

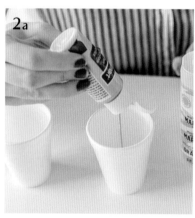

4

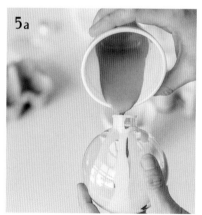

5a

5b

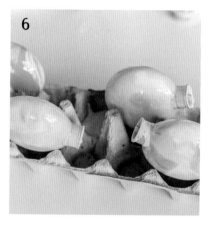

6

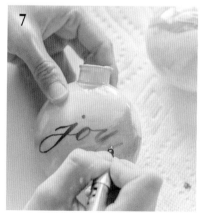

7

Tips and Tricks

+ Choose a variety of acrylic paint colors that you enjoy. For this project, I used white, pale blush and terra-cotta. It's important to choose colors that complement but also contrast. If they're too close to one another, they will blend together really quickly.

INSTRUCTIONS

1 Remove the top of a Christmas ornament.

2 Add one color of paint per plastic cup. Add two parts of the Martha Stewart Crafts Multi-Surface Marbling Medium to one part paint. The marbling medium helps multiply the paint and aids the marbling.

3 Mix the paints and marbling medium together using craft sticks.

4 Add a bit of paint in each color to the inside of the ornament through the hole, and turn it as you drip the paint. Don't add too much paint—just add it a little at a time.

5 Continue turning the ornament until the inside is completely covered with paint.

6 Once you are happy with the design, let the ornament dry pointing downward into an egg carton. You can also adjust the direction of how it dries, as direction will affect how the marbling will look. It may take up to 1 full day for the ornament to completely dry, depending on the amount of paint you've used. Put the ornament's top back on when the paint is dry.

7 Using the Sakura Pentouch paint marker, add some words, names or dates to the Christmas ornaments. Because this wording will be in faux calligraphy, write it first with minimal pressure so that the resulting design will have a thin, even stroke. Then double the stroke on the downstrokes so that you can create variations between the thin and thick strokes. If you are having issues writing on a curved surface like this, use a STABILO All pencil to outline the text; then you can trace it using the paint marker.

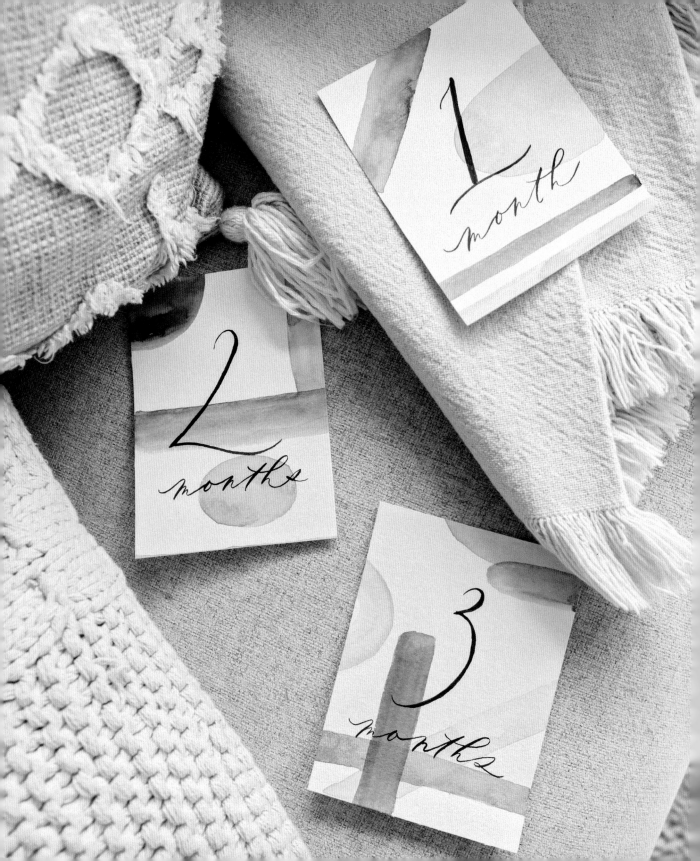

HAND-PAINTED WATERCOLOR
BABY MILESTONE CARDS

Before my little one was born, I frequently searched for beautiful things to add to his nursery and was constantly inspired by botanicals and warm tones. I kept seeing milestone cards photographed next to the baby and thought it was a cute idea, but I didn't realize the meaning of them until my son was born. I realized that those cards were for the parents (or for the mom, really) as an award for surviving that particular number of months the little one had been alive! I also learned to count my blessings so much more when I became a parent. Sleep becomes so precious, the few minutes of sanity is so treasured, that you do want to celebrate when your child has reached the next month. Aside from that, there's this drive to see your child thrive and stay healthy; it feels like a pat on the back when you've made it to the next milestone.

With this project, you will be making twelve milestone cards with an abstract pattern of cohesive colors. You're going to find painting these beautiful shapes to be calming. I also want to share one of my tried-and-true tips in regard to painting abstract shapes, which is to paint them on a larger sheet—then you can cut down the sheet into the sizes of the individual card. That way, you only need to paint three larger sheets!

Supplies

- + Clean dish
- + Round watercolor paintbrush (size 14)
- + Container of water
- + Winsor & Newton Cotman Water Colours palette
- + 9 x 12-inch (22.8 x 30.5-cm) watercolor paper (such as Canson brand)

- + Ruler
- + Pencil (such as a 9H)
- + Scissors
- + Tombow Fudenosuke Soft Tip Brush Pen in black
- + Silk ribbon
- + Keepsake box

How To

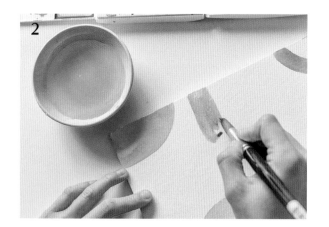

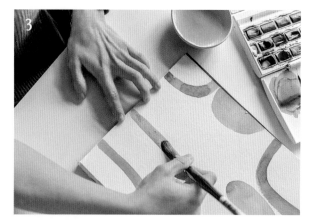

INSTRUCTIONS

1 Prepare the watercolor palette on the clean dish by creating three to four colors that you want to use. Wet the paintbrush as needed in the container of water. I made the following 4 colors:

+ **Pale Beige:** Mix lots of white with a bit of yellow and brown.

+ **Dusty Orange:** Mix some white with the smallest dab of red and yellow.

+ **Taupe:** Mix lots of white with a bit of brown.

+ **Neutral Brown:** Take a bit of Taupe and add more brown to it.

2 On the watercolor paper, use the watercolor paintbrush to paint with the lightest colors and to create various abstract shapes. Try any or all of the following 7 shapes:

+ Half circles

+ Full circles

+ Rainbow strokes

+ Double lines

+ Diagonal lines

+ Rectangles

+ Waves

3 Start with 3 illustrations of each light color, and then move to the darker colors and continue painting.

4 Once the entire creation is dry, use a ruler and pencil to measure and trace a line across the middle of the watercolor paper lengthwise and widthwise.

5 Use scissors to cut the watercolor paper into four (4½ x 6-inch [11.4 x 15.2-cm]) cards.

6 Use the Tombow Fudenosuke Soft Tip Brush Pen to write the number of the month with brush lettering techniques. This means you will need to press down a bit more when you write downward. You will also need to write with only the tip of the brush when you make upstrokes. Be mindful of your top and bottom transition points too.

7 Once you have finished all of the numbers, add the word month or months at the bottom of the card.

8 Tie the cards together with a thin silk ribbon and place the stack in a keepsake box. Now the cards are ready to be gifted!

THE BASICS OF DIGITIZING CALLIGRAPHY

Calligraphy doesn't have to be limited to writing on paper or other similar media. Especially when you're creating multiple copies of work, it's better to digitize your calligraphy and then reproduce it via a printing method. Some surfaces aren't friendly to calligraphy, and printing on the material can be easier and more successful too. For example, I apply calligraphy the most to wedding invitations. Instead of writing on each wedding invitation, I digitize my calligraphy, work on it using a graphic design program and then get the invitations printed. The only part that is written by hand are the envelopes.

Now the big question is, How do I digitize my work? While the process is fairly simple, there are tools that you will need in order to make it happen. Without these tools and some basic graphic design skills, it will be tough to apply the next few skills.

Tools You'll Need

+ Scanner

+ Artwork on smooth paper

+ Laptop or computer with Adobe Photoshop and/or Adobe Illustrator

SCANNER

I have the Epson Perfection V550 Photo scanner. You don't need this scanner exactly to make things work; however, you will need a photo scanner. Typically, the scanners that come in the multifunction printers don't work well, as they are not specialized in scanning photos or artwork. They are best for documents, even though the resolution might be high.

ARTWORK

Of course, you will need your artwork—preferably written on smooth paper, as high contrast as possible for scanning purposes. Typically for calligraphy, I write on Bristol paper in black ink. I make sure that the ink is dry and the artwork is clean (i.e., no pencil marks) before I scan the artwork.

LAPTOP OR COMPUTER WITH ADOBE PHOTOSHOP AND/OR ADOBE ILLUSTRATOR

While I love using my iPad Pro for work, having a desktop computer to work on Adobe Illustrator and Adobe Photoshop is still best. Nowadays, you can sign up for a subscription service with Adobe so that you can use their services on a per-month basis. For some projects, Photoshop will be enough; but for most, you will need Illustrator to create vector files. What do you need Photoshop for? Photoshop can be used to clean up the file to make sure it is easy to use, which means that later it will be easier to trace with.

Process

1 Write your artwork on a clean piece of smooth paper. I recommend using Bristol paper and sumi ink. Sumi ink is very dark and opaque, which is great for scanning. If you have used a pencil and have traced it over with ink, make sure you erase the pencil marks once you are done.

2 Scan your artwork at 600 dpi or higher. Make sure that the scanner's settings are not set to auto color or auto balance; instead, set them to true color or no edits at all. You will be making the changes on your own in Photoshop. Save the scan as a PDF.

3 Open the file in Photoshop. For digitizing black and white, change the mode to Grayscale (Image > Mode > Grayscale). Use the levels to increase the contrast between the paper and ink to ensure that the paper is showing up completely white and the text is showing black or as close to black as possible.

4 Select your artwork and copy and paste it into Illustrator. Select the image, and image-trace it (Object > Image Trace > Make). Ensure you have the Image Trace window open (Window > Image Trace). Toggle the settings until you come to a point that you are happy with the resulting vector file. Following are my preferred settings:

+ A threshold of 135 to 150.

+ Paths and Corners at 75 percent.

+ Noise at 1 percent.

+ Click Expand.

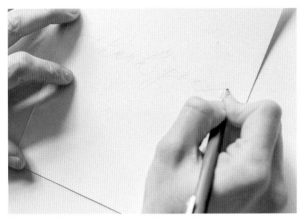

Start with writing your preferred text using a pencil.

Trace over it using a calligraphy pen, nib and ink.

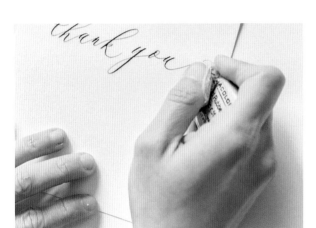

Once the ink is fully dry, remove the pencil marks using an eraser.

Put it in the scanner to scan with high resolution.

5 Use the magic wand to select the white part of your artwork and hit Delete to remove it. Save the file for your project as a PDF.

You can now easily use this file with other programs and create things with it. For example, if you would like to create a rubber stamp, you can use a PDF or even a high-resolution JPG. This stamp was created using rubberstamps.net. I submitted a high-resolution JPG, and they created the rubber stamp for me. I used an archival ink pad and stamped it onto a muslin bag for my packaging purposes. Isn't it cute? The opportunities are endless with calligraphy, and once you can digitize, there is so much more that you can do.

Here's an example of the original artwork, the rubber stamp made from this artwork and the final piece.

TEMPLATES

For additional resources for templates, please visit http://writtenwordcalligraphy.com/booktemplates and use the password: practicemakesprogress.

RESOURCES

WHERE TO GET MATERIALS

General Supplies

+ calligrafile.com
+ dickblick.com
+ johnnealbooks.com
+ paperinkarts.com
+ writtenwordcalligraphy.com

Penholders

+ luiscreations-store.com
+ tomsstudio.co.uk
+ ashbush.com
+ johnnealbooks.com
+ paperinkarts.com
+ writtenwordcalligraphy.com

Cardstock and Envelopes

+ cardsandpockets.com
+ lcipaper.com
+ paperpresentation.com
+ papersource.com

Handmade Paper

+ elivrosenkranz.at
+ idyllpaper.com
+ orangeart.com

RECOMMENDED NIBS

Nikko G	Medium flexibility; sharp, pointy tip; taller nib	Writes like butter, great for beginners. Not great for heavily textured surfaces or thicker metallic inks. I prefer this nib over the Zebra G, which is similar. Ink flows better on the Nikko G, but the nib has slightly thicker upstrokes than the Zebra G. I write with this often when I'm addressing envelopes.
Brause 361 Steno Blue Pumpkin nib	Medium-high flexibility; less pointy tip; taller nib	Ink flows faster, so it is great for thicker metallic inks. Great for textured surfaces. Thicker upstrokes, so it's not recommended for flourishing and more elegant modern calligraphy styles.
Blanzy 2552	High flexibility; moderately pointy tip; taller nib	If you love vintage nibs, this is a beautiful high-quality nib that has stood the test of time. I recommend this nib a lot to students with a lighter hand, as it is very flexible and the upstrokes can be really thin.
Brause EF66	High flexibility; sharp, pointy tip; tiny nib	It is a small nib, yet super flexible. I use it for illustrating rather than writing because it holds so little ink.
Hunt 22	Medium-high flexibility; extra-fine nib	This is my favorite Hunt nib, because I prefer stiffer nibs to write with. This can create the perfect combination of thin and thick strokes for me. I also like to use this nib for illustrating to create fine lines and shading, and it's flexible enough to create thicker strokes if I need to.
Hunt 101	Super high flexibility; sharp, pointy tip	This nib is also great for calligraphers with a light hand, as it can create beautiful, thick downstrokes, and the upstrokes are really thin. I use this nib only when I need to create very thick downstrokes, which is not often. Because it is a Hunt nib, it tends to be scratchier than other nibs.
Leonardt Principal EF	Medium flexibility; fine nib	I love this nib because it's got the flexibility for thick swells, yet it has the similar sturdy feel of the Nikko G.

RECOMMENDED INKS

Black	Sumi ink is best for deep black, archival ink. Best Bottle and Moon Palace are my go-to brands. Higgins Eternal is not as dark, but it's great for beginners and flows easily.
White	Dr. Ph. Martin's Pen-White is my favorite white ink for paper. Another really great option is Dr. Ph. Martin's Bleedproof White, which you will need to water down to the consistency you need. For other surfaces, I like using acrylic white ink, such as Daler-Rowney FW Acrylic Artists' Ink.
Gold; silver; copper	Dr. Ph. Martin's Iridescent Copper Plate Gold is the best straight-out-of-the-bottle gold ink. I love using it! The other colors, Copper and Iridescent Silver, look great from this brand of inks as well.
Sepia	Tom Norton Walnut Drawing Ink is best to achieve this watercolor-esque sepia color.
Red; green; blue	Winsor & Newton's Calligraphy Ink is great for these basic colors.

RECOMMENDED PAPERS

	Great for	Notes
Smooth copy paper	Practicing	Substantial copy paper is sufficient for practicing. Don't choose recycled copy paper, as it tends to be really thin. Usually a minimum of 70- to 80-pound paper works well.
Rhodia paper	Practicing	Superfine vellum paper that is a dream to practice on. A similar brand is Midori MD paper.
Sketch and drawing paper	Practicing; projects	Sketching and drawing paper tend to be thicker and have a smooth surface. They are great to write on. A good option is the Strathmore Drawing pad.
Bristol paper	Projects; digitizing	For archival work, make sure that you choose acid-free paper, so that it will not change color or turn brittle over time.
Watercolor paper	Projects combining other media	Hot press watercolor paper works better for calligraphy because it is smoother, but cold press watercolor paper works well too—you will just need to find a nib that doesn't catch easily.
Cardstock paper	Projects	Higher quality cardstock paper, such as Legion Colorplan and Gmund, work great for writing in calligraphy. These are my go-to options for colored paper, and for projects. I tend to use cover stock paper.
Handmade paper	Projects	Handmade paper has become popular these days, and it is very textured and has gorgeous deckled edges. To write on handmade paper, you'll have to test and see if it works. From my experience, Arpa, Idyll, Share Studios, Silk & Willow and Eliv Rosenkranz papers all write beautifully.
Italian fine paper	Projects	Some select Italian fine papers have beautiful manufactured deckled edges that are amazing to write on. Brands such as Fabriano and Arturo create such paper.
Translucent or tracing paper	Projects	Also called vellum in the wedding stationery world, this paper is easy to write on with a nib, but you will need to test the ink that works best with it. More opaque inks tend to work better.

CRAFT SUPPLIES

Tools	Brands	Where to Find Them
Watercolor palette	Winsor & Newton	Art supply stores; online
Scoring device	No preference	Office supply stores; online
Foil Quill pen	We R Memory Keepers	Amazon; Michaels
Heat-activated foil	We R Memory Keepers	Amazon; Michaels
Silk ribbons	No preference	May Arts Ribbon
Gift boxes	No preference	Michaels; dollar stores
Cardstock	Legion Colorplan; Gmund	cardsandpockets.com; lcipaper.com
Candles; wineglasses	No preference	Homesense; HomeGoods; Target; Etsy
Wax seals	Written Word Calligraphy	writtenwordcalligraphy.com/wax-seal-shop
Sealing wax	Artisaire; Written Word Calligraphy	artisaire.com; writtenwordcalligraphy.com/wax-seal-shop
Dual-heat glue gun	No preference	Amazon; art supply stores; office supply stores
Gold glass display box	No preference	Amazon; Homesense; thrift stores
Embroidery hoops	No preference	Michaels; Amazon; dollar stores
Faux flowers	No preference	Dollar stores; Michaels
Kraft, white, black paper rolls	No preference	Michaels; dollar stores; Amazon
Amber glass bottles	Jamali Garden	jamaligarden.com
Dried flowers	No preference	Local florists; afloral.com; Etsy; home-dried
Polymer clay	Sculpey	Michaels; Amazon; art supply stores
Bottled acrylic paint	Craftsmart	Dollar stores; Michaels
Marbling medium	Martha Stewart Crafts	Michaels; Amazon
Wooden block	No preference	Michaels; Amazon

SUPPLIES FOR WRITING ON MATERIALS OTHER THAN PAPER

Tools	Brands	Great for
Brush pens	Tombow; Kuretake; Pentel	Fabric; wood
White paint pen	Molotow; Montana; Craftsmart; Sharpie; Postila	Wood; glass; acrylic; chalkboard
Gold paint pen	Sakura Pentouch; Postila; DecoColor; Craftsmart	Glass; acrylic; chalkboard
Paintbrushes	Princeton; Winsor & Newton	Most surfaces
Inks	Daler-Rowney FW Acrylic Artists' Ink; Dr. Ph. Martin's Bleedproof White	Most surfaces
Acrylic paint	Winsor & Newton; Schmincke	Most surfaces
Fabric paint	Tulip®	Fabric
Chalkboard pens	Marvy Uchida Bistro Chalk Markers	Chalkboard

ACKNOWLEDGMENTS

I have to start by thanking my awesome and supportive husband, Clement. From listening to my ideas to watching our son, to being understanding when I was stressed writing my book, thank you for being so patient with me through this journey.

Thanks to Brooke, my studio manager, who helped me through every brainstorming, photography, styling and planning session—especially for the photoshoots—and helped me comb through my book for edits. I am forever grateful, because without her the book would not have been completed in such a cohesive manner.

I also want to thank my very good friend and business partner, Heather of Myrtle et Olive, for lending me her expertise in florals and styling to ensure that my book had the best floral arrangements I could ever ask for.

I want to say thanks to my editor, Rebecca, and the rest of the publishing team at Page Street Publishing for working tirelessly throughout this process.

Finally, I want to thank my family, who continuously prayed for me and supported me throughout my book-writing journey.

ABOUT THE AUTHOR

Karla Lim is the owner of Written Word Calligraphy and Design, an internationally recognized wedding invitation and design studio. She has been featured in *Vogue*, *Harper's Bazaar*, *The Knot* magazine, *Brides* magazine and *Martha Stewart Weddings* and has been recognized as a top invitation designer by multiple wedding blogs. She has been practicing modern calligraphy and teaching her passion through calligraphy workshops and online courses for more than eight years. Her calligraphy products and designs have been sold in retail stores around the world, from the United States to the United Kingdom and from Japan to Australia. When she's not busy writing calligraphy, she spends her time with her husband and son.

INDEX